CONTENTS

WHISTLER IN HIS TIME

But you don't mean to say that you seriously believe that life imitates Art,
that life in fact is the mirror, and Art the reality?

OSCAR WILDE

The Decay of Lying, 1899

THESE words by Oscar Wilde, a friend – then foe – of James McNeill Whistler, could easily have been directed at the artist. Whistler cultivated the style of the dandy, exquisite in all matters of taste, from his painting and interior design to cooking and fashion. Art and life directly influenced one another and were often inseparable. From his performances at the famous *Whistler v. Ruskin* trial to his 1885 'Ten O'Clock' lecture on art and aesthetics, Whistler was a born showman. Throughout his career he practised the art of self-promotion, as seen in his manipulation of the press, his brown-paper pamphlets and book, *The Gentle Art of Making Enemies*, the novel exhibitions of his work and, most importantly, through his pose as the 'man about town'.

Born in the manufacturing town of Lowell, Massachusetts in 1834, Whistler frequently felt the need to recreate his humble beginnings citing his birthplace as St Petersburg, Russia or Baltimore, Maryland, claiming 'I shall be born when and where I want, and I do not choose to be born at Lowell'. Such inventions were in keeping with the more cosmopolitan image that Whistler wished to project. Having lived part of his childhood in America and Russia, much of his adult life was spent between the two major capitals of London and Paris. Despite Whistler's claim that 'There never was an artistic period' and that 'There never was an Art-loving nation' ('*Ten O'Clock' Lecture*, 1885), the great cities and their cultural milieu of artists, poets, and writers, had a significant effect on both his life and his art. He was to experience many of the profound social changes we now recognise as the beginning of the modern world and modern art. The intention of this book is to provide an understanding of Whistler the man and the artist in the context of the times he lived through.

Whistler's fame as an artist has been capricious, both during his lifetime and in the last century. One of the problems with his art is that it often defies any neat categorisation. It is perhaps for this reason that he has remained something of an outsider, being neither American, French or English in his work, nor falling into any group movement such as Impressionism. Yet, despite such resistance Whistler was well aware of the artistic trends of his day and was influenced by several of them, from the realist movement of mid-nineteenth-century France to the later currents of the Aesthetic movement.

When Whistler painted this self-portrait 'Arrangement in Grey' of 1872 he had begun to reach maturity as an artist and was evolving an individual style that would surface in his portraits and landscapes of the period. After several years of searching he had at last arrived at an aesthetic formula that would endure for the remainder of his career.

WHISTLER
IN HIS TIME

Anne Koval

Tate Gallery Publications

ACKNOWLEDGEMENTS

This book would not have been possible without the valuable assistance of Miquette Roberts and the technical contribution of Stephen Hackney and Joyce Townsend. Colin Grigg and Richard Humphries provided both inspiration and advice at the inception and later editing stages of the book. Many thanks to Pernilla Nissen, who was meticulous as picture researcher.

A special thanks goes to Linda Merrill at the Freer Gallery in Washington, D.C., to Margaret MacDonald and Nigel Thorpe at the Whistler Study Centre and to Martin Hopkinson at the Hunterian Gallery, University of Glasgow for their generosity in sharing Whistler material. A further acknowlegement of thanks must go to Robin Spencer at St Andrews University and Katherine Lochnan at the Art Gallery of Ontario for their undisputed scholarship.

The translations used in this book are from the following sources: *Charles Baudelaire: The Painter of Modern Life* translated by Jonathan Mayne, © Phaidon Press Limited and Robin Spencer, *Whistler A Retrospective*, Hugh Lauter Levin Associates, New York.

To R.C.

Cover
Detail from 'Nocturne in Blue and Gold: Old Battersea Bridge'
1872

Back cover
Detail from the Peacock Room
Freer Gallery, Washington DC

ISBN 85437 146 0

Published by order of the Trustees by Tate Gallery Publications, Millbank, London SW1P 4RG
Designed and typeset by Roger Davies
© Anne Koval 1994 All rights reserved
Printed in Great Britain by Saunders and Williams

Published to accompany the exhibition organised jointly by the Tate Gallery, London (13 October 1994 – 8 January 1995), the Musée d'Orsay, Paris (6 Febraury – 30 April 1995) and the National Gallery of Art, Washington (28 May – 20 August 1995)

The exhibition at the Tate Gallery is sponsored by Reed Elsevier plc

ℛ
REED ELSEVIER

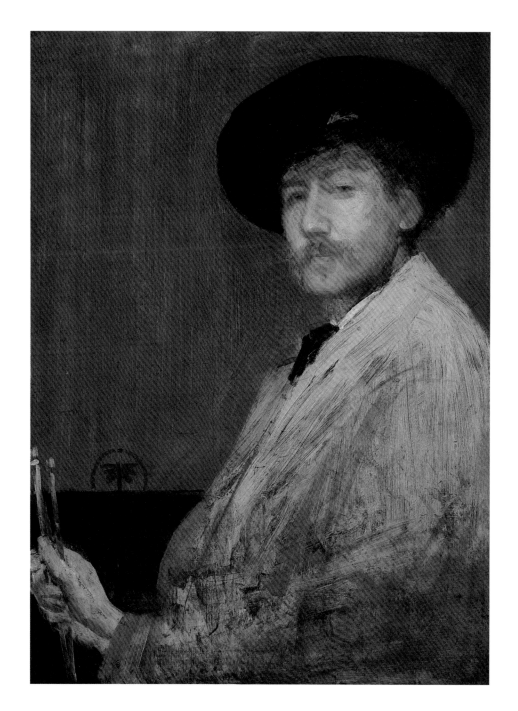

1

WHISTLER

Arrangement in Grey:
Portrait of the Painter
1872, 74.9 × 53.3 cm

Detroit Institute of Art

One of the few self-portraits to
show Whistler in the serious
guise of the artist with
paint-brushes held in hand.

ONE of the most famous images painted by Whistler is the portrait of his mother. It was created during an important transition in his approach away from realism towards a more aesthetic style. This was more than simply the stylistic shift represented by his thinner use of paint and his restricted use of colour. The portrait can be seen as marking a turning point in Whistler's theory and practice with its emphasis on the aesthetic qualities of the work and the absence of any narrative or moral meaning.

Paradoxically, the very fame of the picture rests on what Whistler was so intent on removing, its association with motherhood and patriotism. The painting has come to represent the puritan mothers of America, whose devotion to God and family sustained the early settlers through the hardships of founding a nation. Anna Whistler's diary reveals her as a devoted homemaker and expert cook, but also a devout Protestant, censorious of pleasure. On closer examination of the painting it is this rather austere aspect of her character that the work celebrates. Whistler's picture is nearly monochromatic in its severity and repetition of grey and black, with accents of white. This restricted use of the palette is in keeping with the puritan ethic of visual sobriety and simplicity. When a critic complained of the painting's severity, commenting that the artist should have added a few details, Whistler sar-

Art should be independent of all clap-trap – should stand alone, and appeal to the artistic sense of eye or ear, without confounding this with emotions entirely foreign to it, as devotion, pity, patriotism, and the like. All these have no kind of concern with it; and this is why I insist on calling my works 'arrangements' and 'harmonies'.

Take the picture of my mother, exhibited at the Royal Academy as 'An Arrangement in Grey and Black.' Now that is what it is. To me it is interesting as a picture of my mother; but what can or ought the public care about the identity of the portrait?

WHISTLER

World, 22 May 1878.

2

WHISTLER

Arrangement in Grey and Black: The
Painter's Mother

1871, 144.3 × 162.5 cm

Musée d'Orsay, Paris

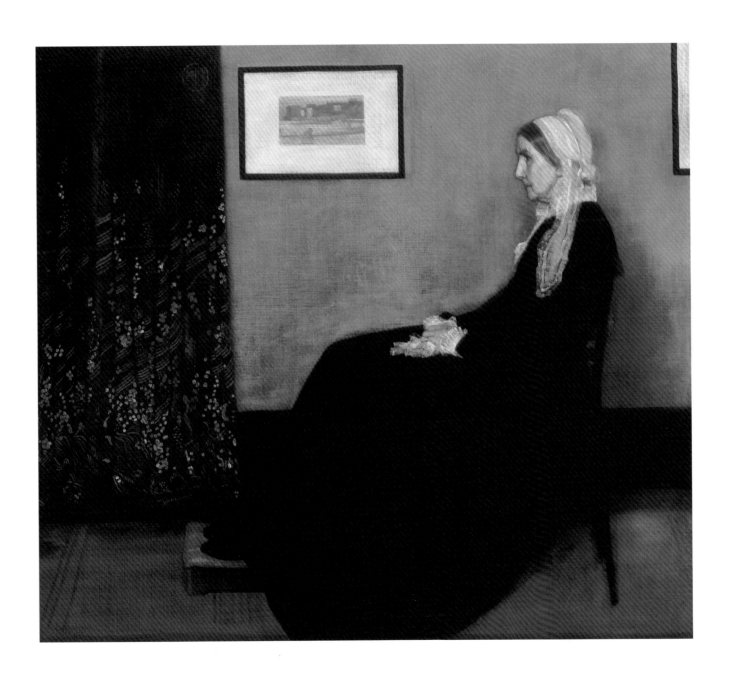

castically suggested that perhaps 'a glass of sherry and the Bible!' would have been appropriate.

How did this painting come to be Whistler's most famous image? In 1891 Whistler took great pains to have the work acquired by the Luxembourg Museum in Paris, where it was eventually housed in the Louvre. This acquisition by the foremost gallery in the world, guaranteed 'Arrangement in Grey and Black: The Painter's Mother' its lasting fame. The work was frequently exhibited during Whistler's lifetime and after his death. In 1934, the centenary of Whistler's birth, the painting toured America under armed guard, where it drew large crowds.

As a famous icon of motherhood in America the image greets us each year in numerous greeting cards for Mother's Day, in advertisements, and in caricatures. From selling motherhood to America, to selling computers, 'Whistler's Mother' has become better known through reproduction than in the original. Another archetypal image of America is Grant Wood's 'American Gothic' (fig. 4) painted approximately sixty year's after Whistler's 'Mother'. Both paintings share the simplicity and austerity associated with a life of hard work and devotion to God.

Whistler's birthplace, Lowell, was a sizeable town on the banks of the Merrimack and Concord rivers. It was a major centre for the textile industry in

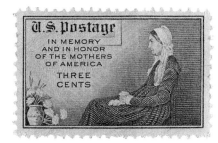

3

Commemorative Postage Stamp in Honour of Mothers

A 3 cent stamp issued in May 1934, in the centenary year of Whistler's birth. Note the addition of chrysanthemums to mark the occasion of Mother's Day. (Enlarged)

New England. This industrial and commercial aspect of the town was abhorrent to Whistler causing him to reinvent his origins. The America of Whistler's childhood was a continent of contradictions. While the Eastern States could boast of elegant cities with Regency architecture and refined social manners, the West remained much of a frontier land. America was a vast and various continent that had gained independence from Britain less than a century before and would undergo a bloody civil war in the 1860s before it began to find a sense of national identity. One of the factors that would assist in bringing the West closer to the East and uniting the North with the South was the great railways. With extensive railway lines, roads and canals crossing the countryside, Americans were constantly on the move, settling and resettling according to their circumstances. Such transience caused a visitor, the French writer Alexis de Tocqueville to comment that 'In America, men never stay still'(*Democracy in America*, 1835). For a family such as Whistler's, where the father, George Washington Whistler, was a chief engineering consultant on the railway, this unsettled lifestyle was the norm. By the time Whistler was nine his family had uprooted and moved four times, the last stopover being the European destination of St Petersburg, Russia.

4
GRANT WOOD
American Gothic
1930
Art Institute of Chicago

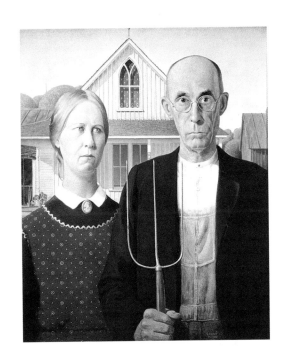

Although only just of age – for if my recollection serve me, it has been a manufacturing town barely one-and-twenty years – Lowell is a large populous, thriving place... nothing in the whole town looked old to me, except the mud, which in some parts was knee-deep... One would swear that every 'Bakery', 'Grocery', and 'Bookbindery' and other kind of store, took its shutters down for the first time, and started business yesterday.

CHARLES DICKENS
American Notes, 1842

5
Whistler's house in Lowell
In 1834 Whistler was born in this colonial house in the expanding community of Lowell, Massachusetts, known for its numerous cotton mills.

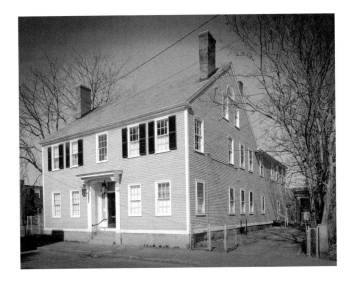

A RUSSIAN CHILDHOOD

The streets abounded in military uniforms, varied and gay as an operetta. The very buildings seemed in fancy dress, with their glittering domes and spires, their carving and colourful tiles. It seemed a city designed, not for use like the substantial American centres, but for a festival or to illustrate a story about Foreign Lands. Not matter how long one lived in Russia, it remained exotic.

E. MUMFORD
Whistler's Mother, 1939

NINETEENTH-CENTURY Russia was still ruled by a wealthy monarchy, which was greatly influenced by European cultural life. St Petersburg was the seat of the monarchy with a court modelled on French manners and palatial buildings which reflected the neo-classical grandeur of the great European cities. These architectural splendours owed much to Catherine the Great, who had many of the French 'empire style' buildings erected during her reign. These included the Academy of Fine Arts and the Hermitage museum to house an impressive collection of great European art.

In 1844 the Whistler family moved to St Petersburg, where Whistler's father had been appointed by Czar Nicholas I to be chief consultant engineer during the construction of the St Petersburg-Moscow railroad. Living in an elegant house by the river Neva the young Whistler was entranced by the splendour of the palatial city with its numerous celebrations and military parades. His fascination with water and with the lavish displays of fireworks would be an enduring one which would later be captured so magically in his Nocturnes of the 1870s.

Yesterday the Empress was welcomed back to St. Petersburg. Last night the illumination which my boys have been eagerly expecting took place...The effect of the light from Vasili Ostrow was very beautiful, and as we drove along the Quai, the flowers and decorations of the large mansions were, I thought, even more tasteful.

Anna Whistler, *Diary*, 30 May 1846

In the spring of 1845 Whistler, aged ten, qualified for entrance to the Imperial Academy of Fine Arts. The Academy like many European counterparts, stressed training in the academic tradition with its emphasis on the study from the antique. Drawing after plaster models in the cast-room was a mandatory practice leading to studies from the life-model (fig. 7). Although Whistler's attendance lasted only a year, this initial contact with the Academy and its emphasis on European (and particularly Italian) art would serve as a foundation on which he would build his knowledge of the arts. Furthermore, his tuition in French, customary for Russian children of the intelligentsia and court circles, would last him a lifetime, and would later facilitate his entrance into the art world of Paris.

It was at the age of fourteen, while staying in London with relatives, that Whistler made known to his parents, still living in St Petersburg, his chosen profession as an artist.

I hope, dear Father, you will not object to my choice, viz. a painter, for I wish to be one so *very* much and I dont [*sic*] see why I should not, many others have done so before. I hope you will say 'yes' in your next [letter], and that dear mother will not object to it.

Whistler letter 26 January 1849,
Glasgow University Library

Their reception of the news was tempered with warnings to moderate his passion for the arts and to direct his

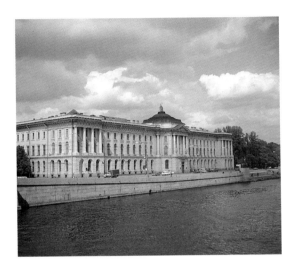

6

Imperial Academy of Fine Arts

Located on the river Neva, opposite the Whistler residence on the English Quay.

7

WHISTLER

Page of Studies

1845/6, pencil 143 × 20.3 cm

Hunterian Art Gallery, Glasgow University

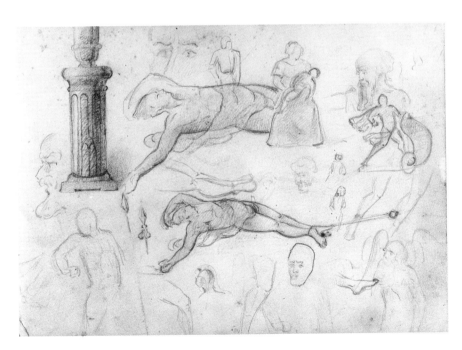

energies towards a career in engineering or architecture. Anna Whistler cautioned her son: 'I only warn you not to be a butterfly sporting about from one temptation of idleness to another.' Family disapproval and financial circumstances meant that Whistler would not be able to actively pursue this ambition until he had come of age in 1855 when he left America to study in Paris.

After the death of Whistler's father in 1849 the family returned to America, where two years later Whistler enrolled at West Point Military Academy. Despite the emphasis on military life, he was able to pursue his passion for art in the drawing class where the emphasis was on topographical and outline drawing. He was briefly employed by the United States Coast Survey in Washington where he learned the basics of etching. His ambition, however, lay in more artistic directions and following his twenty-first birthday, he set off for Paris with a small loan.

Whistler was to join a number of cultural émigrés who travelled to Paris, including such notables as Edgar Allan Poe, Henry James and, much later, Ezra Pound. Many artists and writers turned from what they regarded as the cultural insularity of America towards Europe. While often retaining their American heritage these expatriates, away from their motherland would flourish as artists. It was with such ambitions that Whistler in 1855 took passage for Europe. He would never see America again.

PARIS
TRADITION VERSUS INNOVATION

Our Paris, the Paris where we were born, the Paris of the way of life of 1830 to 1848, is passing away. Its passing is not material but moral ... I am a stranger to what is coming, to what is, as I am to these new boulevards, which no longer smack of the world of Balzac, which smack of London, some Babylon of the future.

GONCOURT BROTHERS

Journal, *18 November 1860*

THE Paris that greeted Whistler was a city in transition. Recovering from the recent political turmoil of the 1848 revolution and the fall of the Second Republic in 1851, the new optimism of the Second Empire under Louis Napoleon Bonaparte began with the reconstruction and modernisation of Paris under the city's prefect, Baron Haussmann. Such a vast transformation, begun in the early 1850s and lasting twenty years, was to have enormous repercussions on the society at large, with the growing bourgeoisie pushing the working classes to the periphery of the city. A contemporary, de Tocqueville wrote of these changes: 'I saw society split in two... No bonds of sympathies existed between these two great classes.' Yet, despite the losses, modernisation made for a cleaner and healthier environment, with grand tree-lined boulevards and wide bridges, imposing multi-storied apartments and fine shopping arcades. For Charles Baudelaire, poet, critic and dandy, the new city represented the 'heroism of modern life'. He wrote encouraging the artist to look to the city for subject-matter.

The painter, the true painter for whom we are looking, will be he who can snatch its epic quality from the life of today and can make us see and understand, with brush or with pencil, how great and poetic we are in our cravats and patent-leather boots.

C. Baudelaire, Review of 1845

Among the artists who celebrated the modern life of Paris were Manet, Degas, Pissarro, Monet and Caillebotte.

Paris was at the centre of an artistic conflict between the traditions upheld by the French Academy, the Ecole des Beaux-Arts, and the Salon and the radical ideas expressed by artists such as Courbet and later Manet and the Impressionists. When Whistler arrived in 1855 this juxtaposition of the new and old regimes was to be epitomised in the Exposition Universelle. With the political aim of promoting the liberal attitude of the Second Empire the exhibition was a showpiece for international industry, commerce and the arts. The fine arts were well represented in the French pavilion by such artists as Ingres and Delacroix. The new regime was represented by an exhibition in a private pavilion marked 'Realism. G. Courbet'. This one-man show of forty works included what was to become Gustave Courbet's most famous picture, 'The Painter's Studio'. Accompanying the exhibition was a manifesto 'On Realism', a political and stylistic movement that rejected academic conventions. The dogmatism associated with neoclassicism and history painting was challenged by Courbet, who insisted that the artist paint what was relevant to his time.

8

FELIX THORIGNY

Demolition of the Rue de Barillerie
for the construction of the Boulevard
de Sebastopol.

After an engraving of 1859, Musée
Carnavalet, Paris

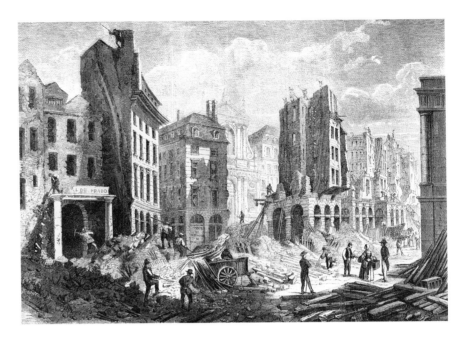

To know in order to be able to create, that
was my idea. To be in the position to trans-
late the customs, the ideas, the appearance
of my epoch according to my own estima-
tion; to be not only a painter but a man as
well; in short, to create a living art – this is
my goal.

Courbet's manifesto 'On Realism', 1855.

Needless to say, when Whistler arrived
in Paris, Courbet, and his 'Realism' ex-
hibition were the talk of the town.
Courbet's personality and philosophy
would soon have an effect on Whistler.

9

Boulevard de Sebastopol, Left Bank
after reconstruction.

After 1859, anon. engraving, Musée
Carnavalet, Paris

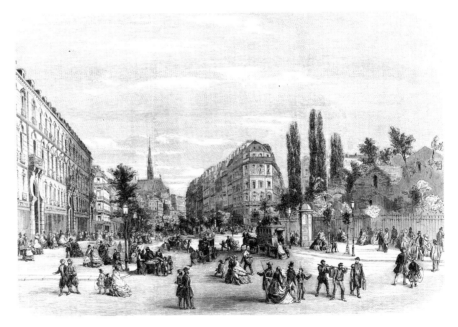

SHAPING OF THE ARTIST

Go to... the old masters, talk to them – they are still alive and will reply to you. They are your instructors; I am only an assistant in their school.

INGRES

AS the capital of the art world, Paris was a major attraction for aspiring artists who wished to begin or complete their education. By the middle of the nineteenth century artists were offered a wide choice of studios, from the Ecole des Beaux-Arts, run by the members of the French Academy to the innumerable private ateliers, which often worked in conjunction with the larger institutes. Experienced artists such as Couture, Gleyre and numerous others, set up these ateliers which often promised a visit from the master once a week.

The largest of these studios, and the dirtiest, was Carrel's [substitute Gleyre], where some thirty or forty art students drew and painted from the nude model every day but Sunday from eight till twelve, and for two hours in the afternoon... One week the model was male, the next female, and so on, alternating through the year. A stove, a model-throne, stools, boxes, some fifty strongly-built low chairs with backs, a couple of score easels and many drawing-boards, completed the *mobilier.*

George du Maurier, *Trilby*, 1894.

Soon after his arrival in Paris Whis-

tler joined the atelier of the Swiss born artist Charles Gleyre. Thoroughly grounded in the academic tradition, – Gleyre, as a teacher, proved to be innovative, encouraging originality in his pupils. Nonetheless, he laid great stress on the importance of preparing the palette, paying special attention to the mixing of tones, a concept Whistler adhered to throughout his career and advocated years later when he himself was a teacher. Another practice that Whistler acquired from Gleyre was the use of numerous paintbrushes, each representing a dominant tone from the palette. Forty years later Whistler would suggest to his students at the Academie Carmen that they name each brush 'Susan', 'Marie', and so forth, to distinguish them. Gleyre also taught his students to use black as a harmoniser, a practice that Whistler would follow in his work. Training the visual memory was another discipline encouraged by Gleyre. This visual training would later affect Whistler's approach to painting his Nocturnes of the 1870s. Finally, and most importantly for the future Impressionists, Bazille, Renoir and Monet, whom Gleyre taught in the early

sixties, he inspired his students to go to nature to make studies *en plein air* for landscape painting.

Part of academic training was for artists to make copies after old master paintings. For many artists it was a way of learning the methods of the master as well as earning much needed money. Whistler made several copies of paintings after old masters including Ingres's 'Roger Rescuing Angelique' of 1819 at the Luxembourg Gallery in Paris. When working as a copyist in the Louvre, Whistler met other artists such as Edgar Degas and Henri Fantin-Latour. In turn Fantin-Latour introduced Whistler to Courbet and Manet. Whistler was to work briefly with Courbet at Bonvin's studio where he began to emulate the older artist in both style and subject-matter. Whistler together with Fantin-Latour and Alphonse Legros, began to fall under the spell of realism and to mark this direction they called themselves the 'Societé de Trois'. Like a group of students in Murger's *Scenes de la Vie de Boheme*, they renounced academic art in their search for individual artistic expression.

10

GEORGE DU MAURIER

Gleyre's studio

From the novel *Trilby* 1894, which
originally depicted Whistler as 'Joe Sibley'
the idle apprentice.

TAFFY À L'ECHELLE!

11

WINSLOW HOMER

Art Students and Copyists in the
Louvre Gallery

Harper's Weekly, 11 January 1868

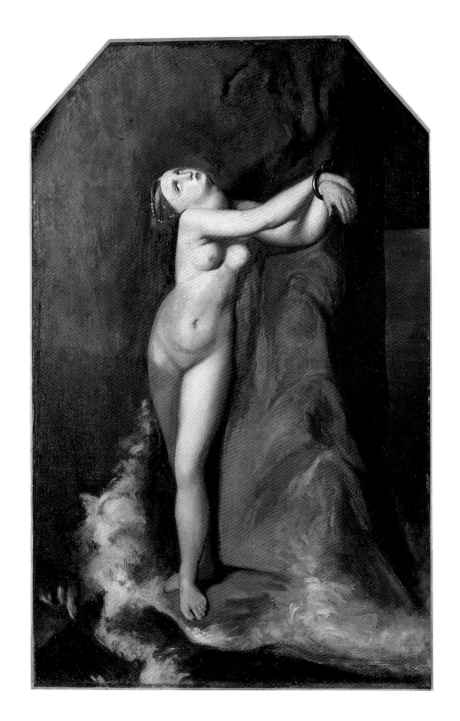

12
WHISTLER
His 1857 commissioned copy after
Ingres's 'Roger Rescuing Angelique'.
82 × 53 cm

Hunterian Gallery, Glasgow

BOHEMIAN OR DANDY?

LIVING in Paris as a young art student Whistler soon acquired the bohemian lifestyle portrayed in Murger's series of literary sketches depicting the artistic life of a poet, painter, musician and philosopher. It was a world of mixed cultures and classes where morals were often flexible and money was always short. In keeping with this romantic image of cheerful poverty Whistler shared a sense of 'bonhomie' with his French and English friends, whom he met in the garret studios and cafés of the Latin Quarter.

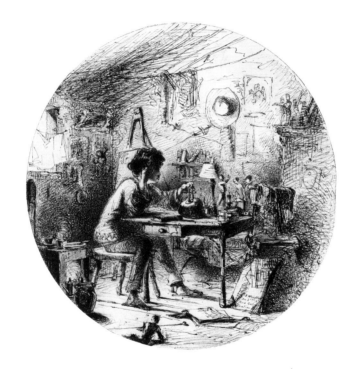

13

WHISTLER

An Artist in his Studio

c. 1856, pen and ink, 23.4 cm diam.

Freer Gallery of Art, Washington DC

Whistler depicts himself in his garret studio located in the Latin Quarter of Paris.

In Paris and later in London Whistler always played the part of the dandy in great style. As an integral part of city life, dandyism had a long history from Sheridan, Brummel and Byron in England, to Barbey d'Aurevilly, Gautier and Baudelaire in France. The subject was of such importance to Baudelaire that he devoted a chapter to it in his 1863 essay 'The Painter of Modern Life'.

Dandyism does not even consist, as many thoughtless people seem to believe, in an immoderate taste for the toilet and material elegance. For the perfect dandy these things are no more than symbols of his aristocratic superiority of mind... It is first and foremost the burning need to create for oneself a personal originality, bounded only by the limits of the proprieties. It is a kind of cult of the self.

Baudelaire, 'The Dandy', from 'The Painter of Modern Life', *Figaro*, 1863

Whistler was not alone in his adherence to the philosophy of the dandy, as other artists such as Manet and Degas attest. The 'cult of self' was a concept Whistler cultivated throughout his life, as epitomised in both his dress and his art.

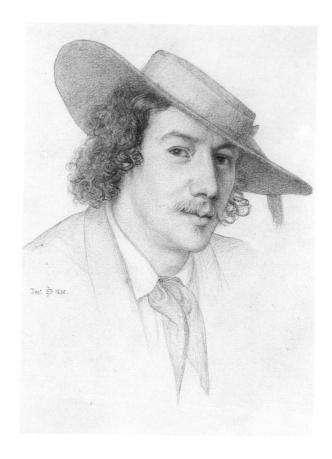

14
E. POYNTER
Portrait of Whistler
Dec. 1858, pencil
Freer Gallery of Art, Washington, DC.

I have a most vivid recollection of my first sight of Whistler... It was in the warm weather of August or September, and he was clothed entirely in white duck (quite clean too!), and on his head he wore a straw hat of an American shape not yet well known in Europe, very low in the crown and stiff in the brim, bound with a black ribbon with long ends hanging down behind. At that time, and long afterwards, the ringlets of his black curly hair were much longer than he wore them when he became well known in London, and the white hairs were not carefully gathered into one lock.

THOMAS ARMSTRONG
'Whistler in Paris' *A Memoir*, 1912

15
Photograph of Whistler (undated)
Freer Gallery of Art, Washington, DC.

IN THIS search for the artist's individuality Whistler painted one of his earliest self-portraits (fig. 16). As an impoverished artist, his own image was the next best thing to that of a paid model. Furthermore the theme of the self-portrait is important and marks for Whistler a crucial point in his career when he began to see himself as a professional artist. By producing this realist image of the artist, Whistler followed a tradition with a provenance which includes the self-portraits of Rembrandt and Courbet along the way.

Whistler's portrait is in keeping with the romantic moodiness of Courbet's numerous self-portraits (fig. 17). The lighting with its emphasis on the planes of the face and the dark tonalities echoes Courbet's work of this period. Whistler's brushwork is loose and the paint on the face is impastoed in the highlights. Yet Whistler's self-portrait is modest when compared to Courbet's monumental 'Studio of the Painter' of 1855, where the artist, sitting at his easel and canvas, serves as the pivotal figure in a vast allegory of his artistic life. Whistler's ascendancy would be rapid, however, and within the decade he would appear in the forefront of a group portrait by Fantin-Latour, 'Homage to Delacroix' (fig. 18), which included other notables such as Manet, Champfleury and Baudelaire.

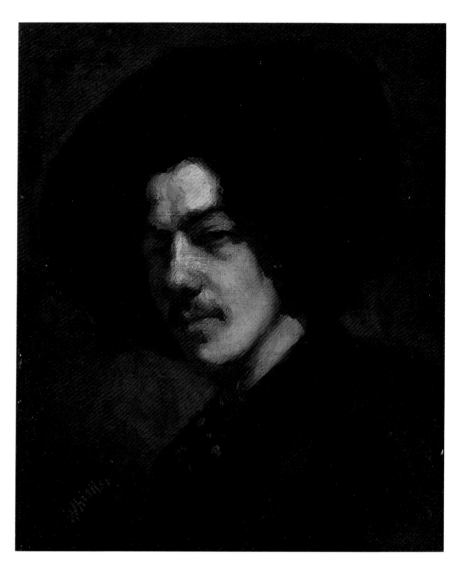

16
WHISTLER
Self-Portrait with a Hat
1857–8, 46.3 × 38.1 cm
Freer Gallery of Art, Washington DC.

17
COURBET
Portrait of the Artist –
The Man with the Pipe
1848-9
Musée Fabre, Montpellier

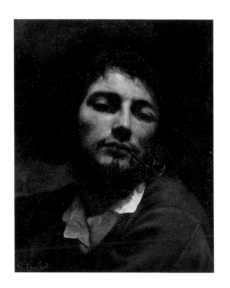

18
HENRI FANTIN-LATOUR
Homage to Delacroix
1864
Musée d'Orsay

Exhibited at the Salon of 1864 where one
French critic pondered the identity of
Whistler, describing him as 'A good-
looking, well-dressed chap, nevertheless'.
Figures include Fantin-Latour seated to the
left of Whistler, Monet standing opposite,
and Baudelaire seated far right.

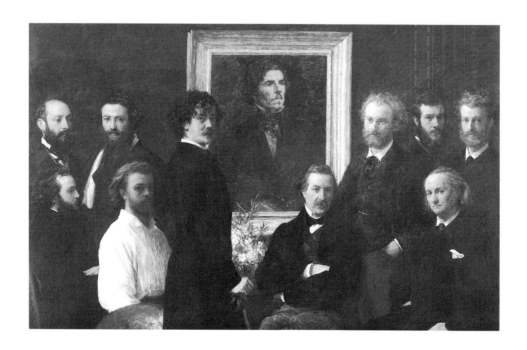

PAINTER OF MODERN LIFE

Far fitter hung over the stove in the studio, than exhibited at the Royal Academy, though it is replete with evidence of genius and study. If Mr Whistler would leave off using mud and clay on his palette, and paint cleanly, like a gentleman, we should be happy to bestow any amount of praise on him... But we must protest against his soiled and miry ways.

On 'La Mère Gérard' exhibited at the Royal Academy, *Daily Telegraph*, 1861

20
WHISTLER
La Mère Gérard
1858, etching from 'French Set',
12.8 × 9 cm
Metropolitan Museum, New York.

IN 1859 Whistler attended his classes with Legros and Fantin-Latour at Bonvin's studio under the direction of Courbet. The influence of realism was at its strongest during this period and one of Whistler's first paintings 'La Mère Gérard' reflects this. The model was a 'Parisian type', a contemporary of Manet's 'Absinthe Drinker'. As victims of the modernisation of Paris by Haussmann, they survived living hand to mouth. Mère Gérard, once the proprietress of a small lending library, was so reduced in circumstances that she survived selling matches and violets at the gates of the Luxembourg Gardens. That Whistler wished her trade to be known is indicated by the inclusion of a flower held in her left hand (fig. 19). The tribute to the earlier realists Rembrandt and Velazquez is evident in both Whistler and Manet's work at this time (fig. 21). In Whistler's painting the treatment of the paint is similar to his self-portrait, with heavier impastoed paint on the headdress of Mère Gérard and in the modelling of the face.

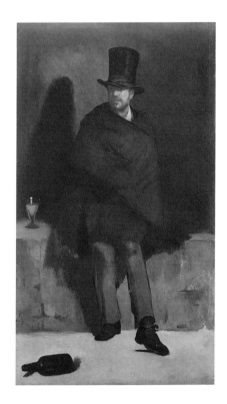

21
EDOUARD MANET
The Absinthe Drinker
1858-9
Carlsberg Glyptotek, Copenhagen.

19
WHISTLER
La Mère Gérard
1858-9,
30.5 × 22.5 cm

Mr and Mrs Solomon, L.A.

22
London, Ludgate Hill.

23
Wapping, *c.*1860.

*The pageant of fashionable life and the
thousands of floating existences –
criminals and kept women – which drift
about in the underworld of a great city...
So there are such things as modern
beauty and modern heroism!*

BAUDELAIRE
'On the Heroism of Modern Life', *1846*

*A town, such as London, where a man may wander for
hours together without reaching the beginning of the
end... This colossal centralization, this heaping together
of two and a half millions of human beings at one
point... has raised London to the commercial capital of
the world, created the giant docks and assembled the
thousand vessels that continually cover the Thames.*

FRIEDRICH ENGELS
The Condition of the Working Class in England, 1844.

IN the spring of 1859 Whistler moved to London where he would soon begin a set of etchings of the Thames. It is conceivable that he had taken his cue from Baudelaire choosing to find the equivalent of modern life in London. Why he chose to leave Paris is unknown. Perhaps the influence of Courbet had become too much for Whistler who was beginning to assert his own independence. In selecting the Thames as subject matter, Whistler was possibly emulating the great French etcher Meryon, whom Baudelaire had recently praised in a review of his work. The Thames provided Whistler with exciting subject-matter to explore both with his etching needle and in paint. The factories, warehouses, and shipping are all portrayed in the realist manner he had acquired under Courbet's guidance. However, by choosing new subject matter, Whistler was able to assert the fact that he was an artist in his own right. His work of this period reveals a fascination with Dockland life, from the innumerable depictions of the working class going about their daily business, to the ships, barges, and boats of all descriptions. In Whistler's etchings of the Thames he has not obscured the fact that this was the industrial centre of London. The figures he portrays all earned their living along the river.

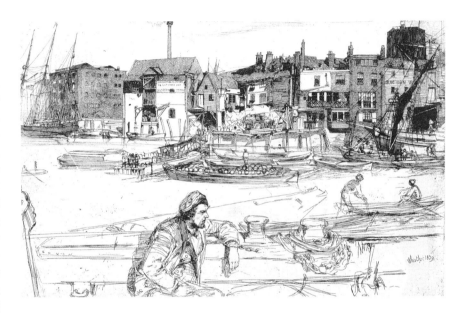

24
WHISTLER
Black Lion Wharf
1859, etching, 15.2 × 22.6 cm
British Museum
Exhibited at the Royal Academy in 1860
and in 1862 at Martinet's Gallery in Paris

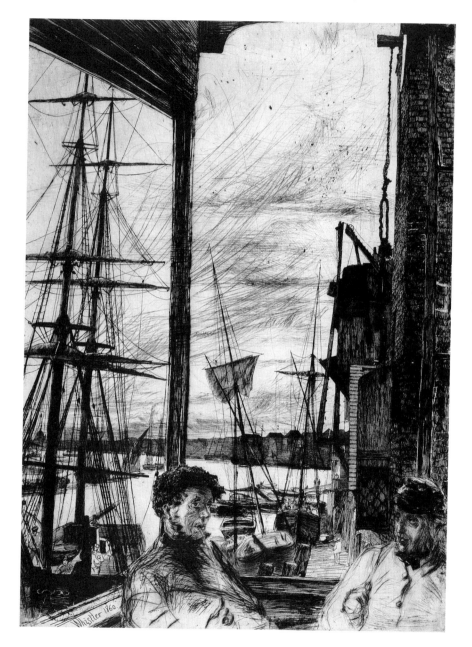

Just the other day a young American art-
ist, M. Whistler, was showing at the
Galerie Martinet a set of etchings, as subtle
and lively as improvisation and inspira-
tion, representing the banks of the Thames;
wonderful tangles of rigging, yardarms and
rope; farragoes of fog, furnaces and cork-
screws of smoke; the profound and intri-
cate poetry of a vast capital.

BAUDELAIRE

'Painters and Etchers', *Le Boulevard*,
14 September 1862

25

WHISTLER

Rotherhithe

1860, etching, 27.5 × 19.9 cm

British Museum

THE Thames during the Victorian period was a site of social and moral significance. The river was associated not only with industry, pollution, the working classes and poverty, but also with low-life, murder, suicide and prostitution. The last became a subject of much interest to politicians, social reformers, writers and artists. The theme of prostitution or 'the fallen woman' became a favourite subject for painters submitting to the annual exhibitions at the Royal Academy. Even within the Pre-Raphaelite circles, that Whistler would soon be frequenting, the motif was being explored by Rossetti, Holman Hunt and Spencer Stanhope. Rossetti's unfinished painting 'Found' of 1853-9, which depicts the story of a country girl turned prostitute, is set near Blackfriars Bridge on the Thames. In Stanhope's 'Thoughts of the Past' of 1859 (fig. 26), a young woman is depicted leaning against her windowsill, beyond which lie the east wharves of the Thames. To the Victorian viewer, the signs of prostitution are to be found in the woman's demeanour, her poverty, and the man's walking stick and glove lying forgotten on the floor beside her foot.

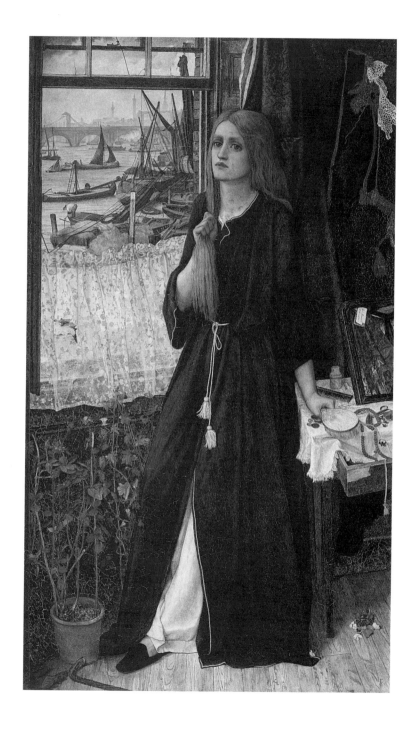

Although the moral aspect of prostitution would have had little appeal for Whistler, the everyday reality of the scenes that he would have witnessed in his expeditions to the docklands, made it a suitable subject for the painter of modern life. Whistler took his task very seriously, moving to lodgings near Wapping in 1861 to have easy access to the Angel Inn, where he chose to set his painting. Du Maurier was to report that Whistler was 'working hard and in secret down in Rotherhithe, among a beastly set of cads and every possible annoyance and misery'. The painting that evolved from this period came to be known simply as 'Wapping' (figs. 27,28). Whistler had plans to exhibit the work within the year, either at the Salon or Royal Academy, however, the painting proved troublesome and took over three years of sporadic painting and repainting to complete. At its inception Whistler wrote a lengthy letter to Fantin-Latour hinting at the subject-matter of a prostitute soliciting a sailor. Describing the woman as 'greatly whorish' with her abundant loose hair and low cut dress, Whistler describes the scene, where she winks at the older man, and true to her

26

R.S. STANHOPE

Thoughts of the Past

1859

Tate Gallery

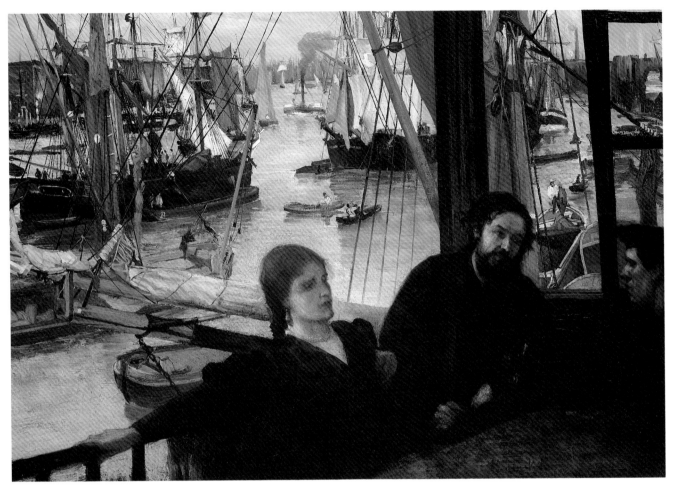

27

WHISTLER

Wapping

1861-4, 71.1 × 101.6 cm

National Gallery of Art, Washington DC, The John Hay Whitney Collection, 1982

Modelled by Whistler's main model and mistress, Joanne Hiffernan with artist
Legros seated beside her.

trade, says, 'All that's fine, old man, I've seen others!'. Whistler is careful to mention twice in the letter that Fantin-Latour must not tell Courbet. This secrecy suggests that Whistler desired to distance himself from Courbet, perhaps fearing that the realist subject might be too tempting for the painter of 'Les demoiselles des bords de la Seine', another prostitution theme, exhibited at the 1857 Salon.

By 1864 Whistler had written to Fantin-Latour that the picture had much changed, with the removal of any obvious narrative reading on the subject of prostitution. An X-ray of this section reveals that originally the man in the middle was seated closer to the woman with his hand around her back. The woman's dress had also changed, Whistler having painted over her revealing decolletage. Such significant changes are indicative of Whistler's move away from overt narrative, possibly influenced by the literary reception of his 'White Girl' in 1862.

Despite Whistler's changes, when the painting was exhibited at the Royal Academy in 1864, it was met with disapproval from the critics. The Royal Academy was a stronghold for British art and the reception of a picture could either make or break an artist's reputation. In 1860 Whistler's painting 'At the Piano' had met with great approval and was actually purchased by a Royal Academician, John Phillips. Had Whistler

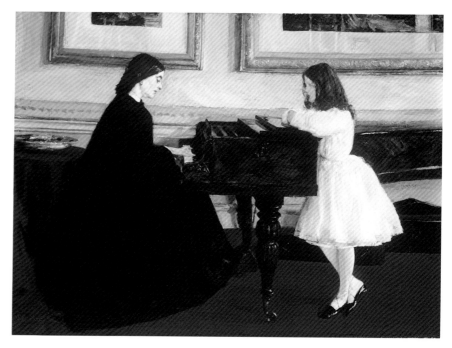

28
WHISTLER
At the Piano
1858-9, 67 × 91.6 cm
Taft Museum, Cincinnati, Ohio.

Exhibited at the Royal Academy in 1860 to a positive reception. Depicting his half-sister Deborah Haden and her daughter Annie, this scene of quiet domesticity reflects the work of Fantin-Latour. The contrast between Whistler's bourgeois life-style at the Haden's and his bohemian existence in Wapping are striking.

Technique

'Wapping' is a good example to compare with Whistler's later technique. Rather than being restricted to a few hues, it contains a wider range of colours than later works. It is more thickly painted than his later work and involves some glazing. His attempts to alter the figures by overpainting have created a discoloured and darkened area quite out of key with the rest of the work. Oil paint darkens on initial drying and any new paint applied to match the dried oil will darken relative to it. Worse still, the thick paint has cracked. In later finished work Whistler painted more thinly and went to great lengths to avoid reworking.

STEPHEN HACKNEY AND JOYCE TOWNSEND
Tate Gallery Conservation Department

continued in this vein of portraying a domestic middle-class interior, his acceptance into the Academy would have been been facilitated. However, with unconventional pictures such as 'Wapping' and his later portrait, 'The Painter's Mother', such approbation would not be his.

It is a pity that this masterly background should be marred by a trio of grim and mean figures. There are noble-looking merchant sailors and fair women even among the crowd of Ratcliff-highway. But it is Mr Whistler's way to choose people and things for painting which other painters would turn away from, and to combine these oddly chosen materials as no other painter would choose to combine them. But even such power as Mr Whistler's does not excuse his defiance of taste and propriety. He should learn that eccentricity is not originality, but the caricature of it.

Tom Taylor, *Times*, 5 May 1864, on Whistler's 'Wapping'.

29
WHISTLER
Detail of 'Wapping', fig. 27

'THE WHITE GIRL'

*Well, you know, it was this way. When I came to London I was received graciously by the painters.
Then there was coldness, and I could not understand. Artists locked themselves up in their studios –
opened the doors only on the chain; if they met each other in the street they barely spoke. Models went
round silent, with an air of mystery... Then I found out the mystery: it was the moment of painting the
Royal Academy picture. Each man was afraid his subject might be stolen. It was the great era of the
subject.*

WHISTLER
The Royal Academy subject, Pennell's *Journal.*

IN the early sixties when Whistler was attempting to establish himself on the art scene the primary venues for exhibiting were the Royal Academy in London and the Salon in Paris. The 'subject' picture was of primary importance with the predominance of history paintings at the Salon matched by the profusion of genre paintings at the Royal Academy. To the general public, the purpose of a picture was to tell a story, either as a literary illustration or as a moral narrative.

When Whistler submitted his painting 'The White Girl' (fig. 30) to the 1862 Royal Academy selection committee it was rejected. In its loose treatment of the paint on canvas, the picture would have been regarded as unfinished. More problematic, however, was the ambiguity of the image of a young woman dressed in white standing on a wolf-skin rug in front of a white curtain, holding a flower. To the average viewer, versed in reading a story into a picture, Whistler's painting was to prove a puzzle.

Furthermore, the picture defied any categorisation being neither portrait nor genre painting. Despite this ambiguity Whistler was able to find a venue for the painting at Morgan's Gallery in Berners Street, London, where it was given the title 'The Woman in White' by the directors. As a result the picture was associated with Wilkie Collins's recently serialised novel of same title. The popularity of the novel with its mysterious figure of 'The Woman in White' at the centre of the story, caused quite a sensation and was well known when Whistler painted his picture. Yet, when the critic of *Athenaeum* pointed out the link, Whistler wrote his first letter to the press disputing this.

It is one of the most incomplete paintings we ever met with. A woman, in a quaint morning dress of white, with her hair about her shoulders, stands alone, in a background of nothing in particular ... The face is well done, but it is not that of Mr Wilkie Collins's *Woman in White*.

F.G. Stephens, *Athenaeum*, June 1862

I had no intention whatsoever of illustrating Mr Wilkie Collins's novel; it so happens, indeed, that I have never read it. My painting simply represents a girl dressed in white standing in front of a white curtain.

Whistler, letter to *Athenaeum*, 1 July 1862.

The following year he decided to show the work in Paris and submitted the painting to the jury committee at the Salon. Again, his picture 'The White Girl' was rejected. Since 1852 the Salon had become increasingly conservative in its selection and the chance for a lesser known artist's work being accepted became more remote each year. In 1863 the severity of the jury selection was such that more than three-fifths of the works were refused, causing the Emperor to order an alternative exhibition for the rejected work to be held in the galleries next to the official one. When Whistler heard of this opportunity he submitted his work, where it was hung in a prominent position. The exhibition, which was known as the *Salon des Refusés* opened on 15 May and attracted huge crowds,

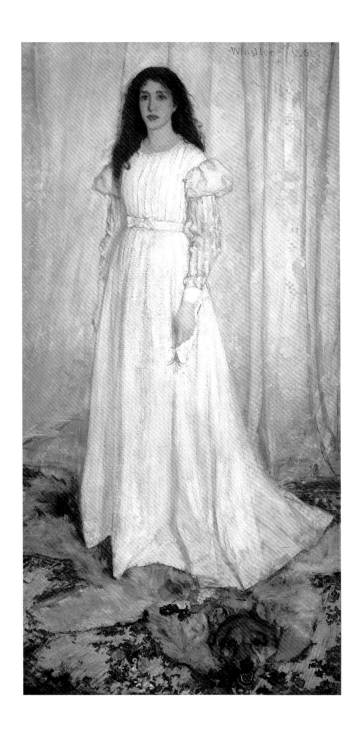

30
WHISTLER
Symphony in
White, no. 1: The
White Girl'
1862,
214.6 × 108 cm
*National Gallery,
Washington DC.*

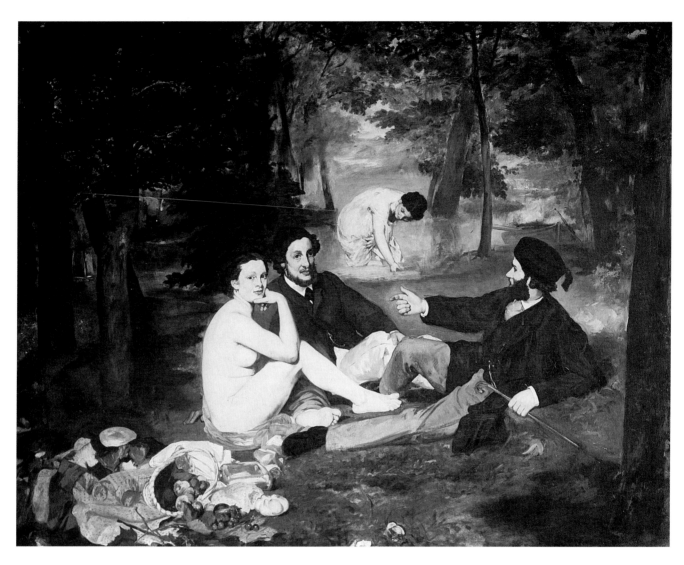

31

EDOUARD MANET

Le Déjeuner sur l'herbe

1863

Musée d'Orsay, Paris

Mr Whistler's picture does not contain merely an association of tones which possibly will seduce only sophisticates; it also has a poetry of its own. Whence comes this white apparition? What does she want from us with her dishevelled hair, her great eyes swimming in ecstasy, her languid pose and that petal-less flower in the fingers of her trailing hand? No one can say: the truth is that Mr Whistler's work works a strange charm: in our view, the 'Woman in White' is the principal piece in the heretics' Salon.

Paul Mantz, 'Salon of 1863', *Gazette des Beaux-Arts,* July 1863

everyone curious to see the rejected pictures. Manet exhibited three pictures including his painting 'Le Bain' which came to be known as 'Le Déjeuner sur l'herbe'. This painting attracted the attention of the visitors to the galleries and the derision of many of the critics. The subject was pronounced 'indecent' by the Emperor and the public agreed with him. If the curious subject-matter of a naked woman picnicking with two clothed men was enough to arouse the derision of the public, Manet's manner of painting in a broad and summary fashion brought further disapproval. Likewise, Whistler's 'White Girl' attracted much scornful ridicule from the crowd, with Zola noting that 'folk nudged each other and went almost into hysterics; there was always a grinning group in front of it' (*L'Oeuvre*, 1886). Perhaps what most irritated the critics and public alike, beyond the painterly treatment, was the fact that both paintings deviated from any conventional reading and remained ambiguous in subject.

Mantz further described the 'White Girl' as 'a symphony in white', a title that was to be used by Whistler in 1872. This link between music and colour was currently being explored by a number of poets of the period including Gautier and Baudelaire. The theme would soon come to feature in all of Whistler's work.

The critic Castagnary questioned the inclusion of the flowers and the wolf-skin and interpreted the picture as depicting the loss of virginity. The white lily, held in her left hand, a flower traditionally associated with purity, helped to support such a reading. Yet the picture still remains a mystery to the viewer. Another critic wrote:

It is a portrait of a spiritualist, of a medium. The figure, the attitude, the physiognomy, the colour, are all strange. It is both simple and fanciful; the face has a haunted and charming expression which attracts the attention. There is something shadowy and profound in the gaze of this young woman whose beauty is so peculiar that the public does not know whether to find her ugly or beautiful.

F. Desnoyers, *Salon des Refusés*, 1863

As a realist, Courbet, who once mocked that if he saw an angel he would paint it, did not approve of Whistler's 'apparition du spiritisme'. Perhaps he sensed that his pupil was moving further away from realism and closer to the more esoteric work of the Pre-Raphaelites. While Whistler's work has none of the religious or moral overtones of their earlier paintings, certain parallel interests do exist. By the summer of 1861 he had already begun to work on the painting which came to be known as 'Wapping', with its implied theme of prostitution. The theme of 'the fallen woman' was being explored by several of the Pre-Raphaelite painters, with Holman-Hunt's 'The Awakening Conscience' as perhaps the most overtly moral and symbolic. The spiritual element found by the French critics in Whistler's 'White

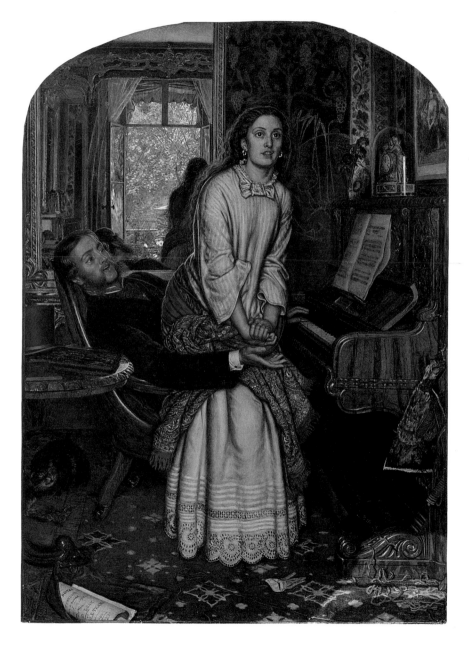

Girl' was also being explored by Rossetti in his painting 'Beata Beatrix'. Both artists shared a passion for accessing the spirit world through the seances they were to perform when living in Chelsea. Whistler's movement away from realism can be documented through images of Joanna Hiffernan, a Pre-Raphaelite type with her abundant red hair and artistic dress, as seen in his painting 'The Little White Girl'.

32

WILLIAM HOLMAN HUNT

The Awakening Conscience

1853

Tate Gallery

A picture laden with symbolic readings on the theme of the 'fallen woman'.

33

WHISTLER

Symphony in White, no. 2:
The Little White Girl

1864, 76 × 51 cm

Tate Gallery

The second painting in a series of three
continuing the theme of white which was
later linked by the musical title. Whistler's
growing interest in collecting Oriental *objets
d'art* is apparent in the pottery and fan.

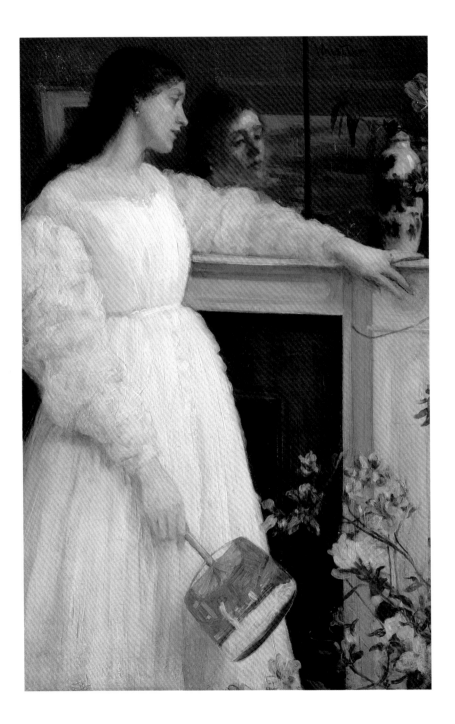

'ART FOR ART'S SAKE'

*The story of the beautiful is already complete – hewn in the marbles of
the Parthenon – and broidered, with the birds, upon the fan of Hokusai
– at the foot of Fusiyama.*

Whistler, 'Ten O'Clock' Lecture, 1885.

WHEN Whistler settled in London in the early sixties it was a period which has been regarded as the dawn of the Aesthetic Movement. Unlike other artistic movements, there was no manifesto or organised group; it grew rather like a trend in fashion. Some of the earlier recruits came from the Pre-Raphaelite circle, notably the later generation of Edward Burne-Jones and William Morris. The overlapping of artist and designer, and blurring of distinctions between fine art and craft were all part of this greater movement. Perhaps the most central tenet, however, related to beauty for its own sake. Whistler, who was partly responsible for the advent of aestheticism, was the perfect practitioner, living his life according to his art. His work soon began to adapt to the more aesthetic sensibility of Rossetti and another artist within his circle, Albert Moore. The exoticism of Rossetti's work of the 1860s and the refined classicism of Moore's paintings captured Whistler's imagination.

With the opening up of the East in the late 1850s the collecting of Japanese prints and Chinese porcelain had spread from Holland and Paris to London. Whistler, an early collector, inspired Rossetti, who soon began vying for prize acquisitions. Whistler's fascination with the Orient, coupled with Moore's interest in Greek sculpture and Tanagra figures, was to create a unique combination of styles and influences that affected their work of this period (fig. 34).

Whistler met Albert Moore in 1865 and over the next few years grew very close to the British artist. Moore, whose early work was Pre-Raphaelite in character, had recently visited Rome where he was influenced by classical sculpture. On his return to England his painting began to reflect this interest, showing classically draped figures in decorative settings (fig. 35). These harmonious works had a loose affinity with the neo-classical movement then current in British art circles, including the work of Leighton and Alma Tadema. Yet Moore and Whistler were to deviate from the Victorian love of narrative and adhere more strongly to the aesthetic principle of 'art for art's sake'.

In the few years that followed Whistler exhibited no paintings but experi-

34
Photograph of Tanagra statuette
in the Ionides collection, from an
album in Whistler's possession
*Hunterian Art Gallery, University of
Glasgow*

35
ALBERT MOORE
A Garden
1869
Tate Gallery

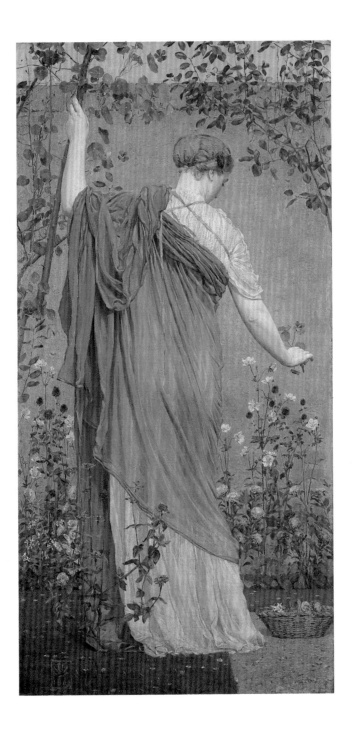

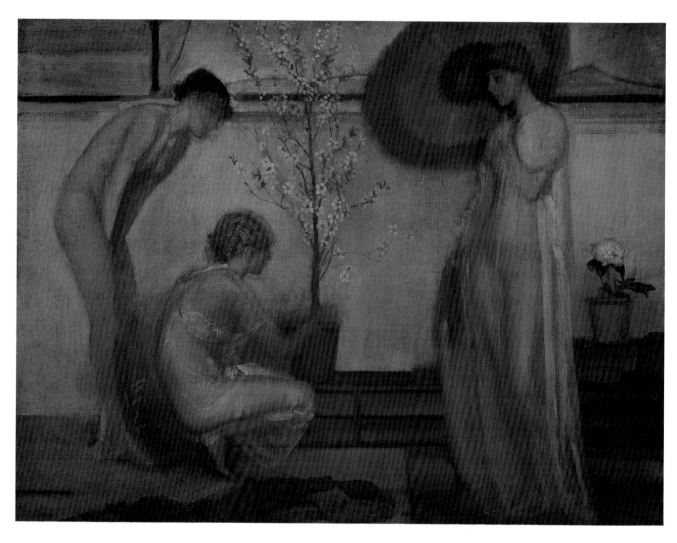

36

WHISTLER

Pink and Grey: Three Figures

Possible copy after 'Three Girls'

c. 1868–79, 139.7 × 185.4 cm

Tate Gallery

mented with colour harmonies and decorative work. One decorative scheme known as the 'Six Projects' was originally intended for the London house of his patron, the collector F.R. Leyland. Although the design scheme was never completed a series of colour sketches and one large canvas, 'Pink and Grey: Three Figures' still exist (fig. 36). Judging from these pictures Whistler intended the complete scheme to form a series, reminiscent of Japanese prints (fig. 37). Whistler's adherence to some of the principles found in these prints, with their repetition of colour, appears to be central to his planning of the 'Six Projects'.

It seems to me that colour ought to be embroidered on the canvas, that is to say, the same colour ought to appear in a picture continually here and there, in the same way that a thread appears in an embroidery, and so should all the others, more or less according to their importance; in this way, the whole will form a harmony. Look how well the Japanese understood this. They never look for the contrast, on the contrary, they're after repetition.

> Whistler to Fantin-Latour,
> 30 September 1868

Whistler was to find a sympathetic reviewer in his friend, the poet C.A. Swinburne. Although Whistler was not exhibiting at this time, Swinburne was to write a sensitive review of his paintings, particularly of the colour sketches. Music or verse might strike some string accordant in sound to such painting, but a mere vision such as this is as a psalm of Tate's to a psalm of David's. In all of these the main strings touched are certain varying chords of blue and white, not without interludes of bright and tender tones of floral purple or red.

> Swinburne, 'Notes on The Royal Academy
> Exhibition, 1868'

On Moore's work Swinburne wrote: 'His painting is to artists what the verse of Theophile Gautier is to the poets, the faultless and secure expression of an exclusive worship of things formally beautiful.' Such a view reflected the French idea of 'art for art's sake' and the theory of *Correspondances*, or synaesthesia, according to which one art corresponds with another, a concept developed by Gautier and his great successor Baudelaire.

The link that Swinburne was establishing between music and colour was one which Whistler was evolving in his own work and which allowed his theory to come closer to his practice. In the years to follow Whistler would rename all his paintings with musical titles in relation to their colour schemes, a practice that would contribute to the further distancing of his work from any narrative intention.

37
UTAMARO
Girls on a bridge
(1753-1806)
Japanese woodcut print.
British Museum

THE NOCTURNES

And when the evening mist clothes the riverside with poetry, as with a veil, and the poor buildings lose themselves in the dim sky, and the tall chimneys become campanili, and the warehouses are palaces in the night, and the whole city hangs in the heavens, and fairy-land is before us – then the wayfarer hastens home; the working man and the cultured one, the wise man and the one of pleasure, cease to understand, as they have ceased to see, and Nature, who, for once, has sung in tune, sings her exquisite song to the artist alone, her son and her master – her son in that he loves her, her master in that he knows her.

Whistler, 'Ten O'Clock' lecture, 1885

Whistler's Nocturnes are arguably his most original work. They evolved after a period of experimentation with colour harmonies as seen in his 'Six Projects' when he returned to painting the Thames. However, unlike his earlier etchings and paintings of the river Whistler imposed a more refined sensitivity to atmosphere and tonal colour. In Whistler's Nocturnes the Thames is transformed from a river of industry and shipping to a vision of beauty. Such paintings would later inspire poets such as Oscar Wilde, William Ernest Henley and Arthur Symons to write poems in their spirit.

39
WHISTLER
Detail of frame for fig. 38.
Note the mackerel pattern and Whistler's butterfly signature as a part of the overall design.

38
WHISTLER
Nocturne in Blue and Gold: Old Battersea Bridge
1872,
66.6 × 50.2 cm
Tate Gallery

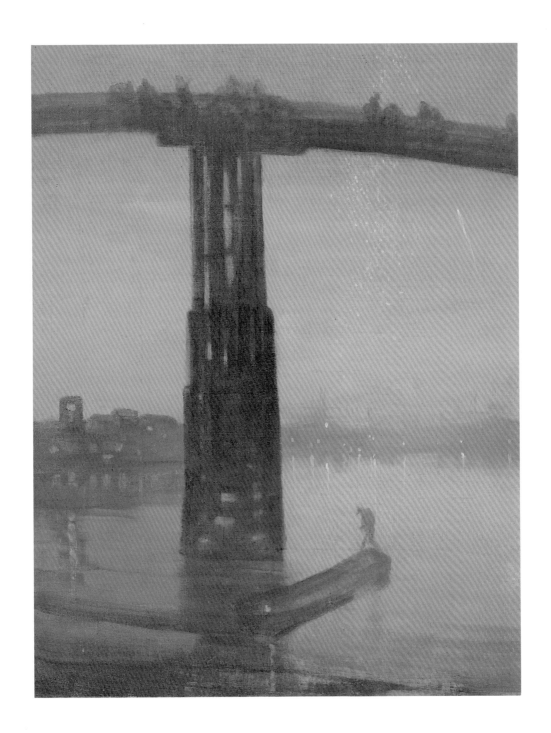

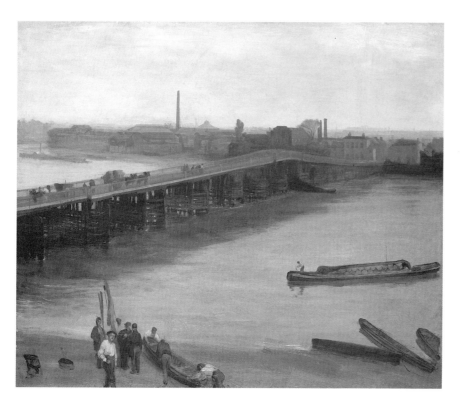

40

WHISTLER

Brown and Silver: Old Battersea
Bridge

1863, 63.5 × 76.2 cm

Addison Art Gallery, Andover, Mass.

The bridge in this earlier realist version is
almost beyond recognition in the later
version.

WHEN comparing Whistler's earlier painting of Old Battersea Bridge (fig. 40) to his later version (fig. 38) a radical change is apparent. This shift in the visual construction is due to his close study of Japanese woodcut prints (fis. 41,42). The elongation of forms, as seen in the wooden pier of the bridge, has changed dramatically in the two versions. The perspective has shifted from a literal description of a scene with the bridge cutting a diagonal across the canvas, to one where the shape of the bridge forms an almost abstract design on the canvas. The bargeman in the earlier canvas and the workers on the shore are all represented in a realist fashion. However, in the later Nocturne the bargeman who drifts under the bridge is similar to the Oriental figure found in numerous Japanese prints. Part of this simplification of forms came about through Whistler's use of a 'memory method', where the eye and mind were trained to recall the original image. Such methods were taught in Paris by Lecoq de Boisbaudran, who had once instructed Fantin-Latour. Whistler's old teacher Gleyre also encouraged this practice. Such methods encouraged the student to memorise objectively the scene or object before them, then to draw from the visual memory.

41

HIROSHIGE

'Kyobashi Bridge' from *One Hundred Views of Edo*

c. 1857, woodcut

British Museum

42

SHUNTOSAI

Fireworks over Bridge

1857, woodcut

Glasgow University Library

Belonging to Whistler's studio

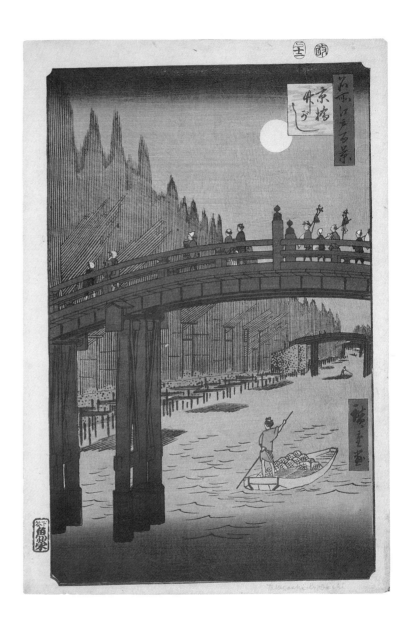

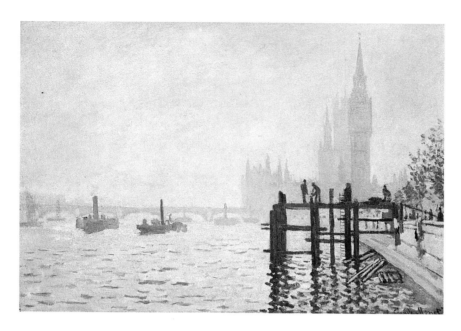

43

MONET

The Thames and Houses of Parliament

1871

National Gallery

Painted when he first visited London during the Franco-Prussian War. Monet was so intrigued by the atmosphere of London fogs and the river that he would return at the turn of the century to paint the subject. Monet would have painted the scene in the open air, unlike Whistler's memory method.

We had left the studio when it was quite dusk... when he suddenly stopped, and pointing to a group of buildings in the distance, an old public-house at the corner of the road, with windows and shops showing golden lights through the gathering mist of twilight, said 'Look'! ... and after a long pause he turned and walked back a few yards; then with his back to the scene at which I was looking, he said, 'Now, see if I have learned it,' and repeated a full description of the scene, even as one might repeat a poem one had learned by heart.

T.R. Way, *Memories of James McNeill Whistler*, 1912

Employing this memory method allowed Whistler to seek the essential aspects of a scene, resulting in a simplification of his design. On occasion he might make a little chalk note, but the image and colour were retained through memory. Then he would return to his studio and the following day paint his picture. This studio practice was at odds with that of his contemporaries Monet, Pissarro and several others of the group soon to be known as the 'Impressionists', who sought to record directly from nature *en plein air* (fig. 43).

Technique

'Nocturne in Blue and Gold' (fig. 44) is painted on canvas. Whistler bought prepared canvases or panels from a variety of colourmen and some were prepared by his pupil Walter Greaves. It has a commercial lead white oil ground which was then overlaid with a thin warm ground of lamp black and lead white. Whistler chose his grounds

carefully. The warm mid-tone ground is most easily seen in the water in the reflection of the bridge. He spent some time mixing his 'sauce', a mixture of drying oil and mastic diluted with much turpentine. He experimented with several mixtures which involved adding resins to prevent sinking and loss of gloss. Prussian blue and lead white are the dominant pigments, but lamp black, madder, red organic pigment are also present. He made up sufficient paint for the entire work, on a large palette or in a gallipot. He applied it with a flat-ended brush, perhaps half an inch wide, in controlled horizontal strokes. To prevent the paint from running, the canvas would have been placed flat until it was dry.

This is a more finished composition than some other Nocturnes: the present image has been extensively scraped down and reworked. The canvas weave tops were abraded in this process and are now exposed in places. An earlier composition on this canvas is just discernible in an X-radiograph. There is an earlier depiction of fireworks which has been partly rubbed out and replaced by the present ones. The most prominent rocket was applied onto wet paint and rubbed to form its tail. By contrast, the yellow of the window lights is painted over dried paint and was presumably added later.

STEPHEN HACKNEY AND JOYCE TOWNSEND
Tate Gallery Conservation Department

44
WHISTLER
Detail, 'Nocturne in Blue
and Gold'.

46
WHISTLER
Cremone Gardens, No. 2
c. 1875, 68.5 × 135.5 cm
Metropolitan Museum of Art, New York

What enjoyable evenings those were when we used to sit with Whistler at the window of the hotel and look down on the wonderful scene below; the whole place ablaze with thousands of lamps, and the crowds of dancers, with their multi-coloured dresses, all moving around the brilliantly lighted bandstand to the strains of the 'Derby Gallop' and the noted waltzes of the day.

Walter Greaves, 1912

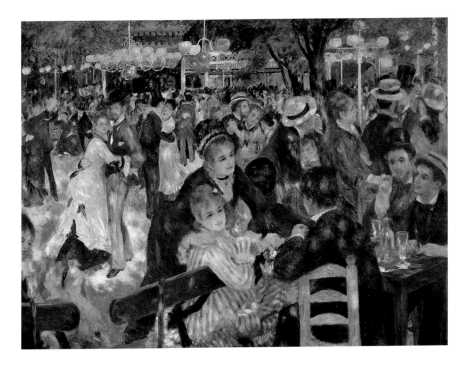

47

RENOIR

Dancing at the Moulin de la Galette

1876

Musée d'Orsay, Paris

Compositionally, the spectator is a
participant in the scene, unlike Whistler's
Nocturnes where the view is set back, like
a stage piece.

ALONG the Thames, one of the sites
that intrigued Whistler was the
pleasure garden at Cremorne, which he
visited frequently during the sixties and
seventies. Opened in 1845, Cremorne
Gardens became a notorious meeting
place for late-night revellers, and soon
gained a dubious reputation, which
caused its closure in 1877. Catering to a
broad sweep of classes, the entertainment
included aerial balloon acts, dancing,
and theatricals, and every night a grand
display of fireworks would light up the
site for all to see along the Thames. Such
a vision inspired Whistler to paint his
most abstract pictures of night.
Cremorne Gardens offered Whistler the
nearest visual equivalent in London to
the outdoor cafés and cabarets in Paris,
painted by his contemporaries Manet,
Degas and Renoir. In Whistler's depic-
tions of 'modern life' the colour and gar-
ishness of Cremorne are refined into an
elegant set-piece which has more in com-
mon with eighteenth-century painters
such as Watteau, than with contempo-
raries such as Renoir.

45

Marriott, 'Cremone Quadrilles

1850s, lithograph

Chelsea Library

*For the perfect flaneur, for the passionate
spectator, it is an immense joy to set up
house in the heart of the multitude, amid
the ebb and flow of movement ... to be at
the centre of the world, and yet to remain
hidden from the world – such are a few of
the slightest pleasures of those independ-
ent, passionate, impartial natures which
the tongue can but clumsily define.*

Baudelaire, 'The Painter of Modern Life', 1863.

48
WHISTLER
Nocturne: Black and Gold –
The Falling Rocket
1875, 60.3 × 46.6 cm
Detroit Institute of Fine Arts

For Whistler's own sake, no less than for the protection of the purchaser, Sir Coutts Lindsay ought not to have admitted works into the gallery in which the ill-educated conceit of the artist so nearly approached the aspect of wilful imposture. I have seen, and heard, much of cockney impudence before now; but never expected to hear a coxcomb ask two hundred guineas for flinging a pot of paint in the public's face.

John Ruskin, *Fors Clavigera*, 2 July 1877

ONE of Whistler's most famous paintings and his most abstract is better known by the title 'The Falling Rocket'. It was first shown in 1877 at the inaugural exhibition at the Grosvenor Gallery, newly established as an alternative venue to the Royal Academy, along with seven other works by Whistler. The paintings exhibited, (by invitation only) included works by Burne-Jones, Leighton, Moore, Watts and others. The art critic John Ruskin reviewed the show and wrote a scathing review of Whistler's work in the journal *Fors Clavigera*, which prompted the artist to sue Ruskin for libel. The ensuing *Whistler v. Ruskin* trial of 1878 became a public platform for Whistler to articulate his theory of 'art for art's sake'. The trial took place over two days with a jury of twelve men in a courtroom crowded with press and a curious public, who came to witness the eccentric James McNeill Whistler take on one of the most re-spected art critics of the Victorian period. If they were disappointed by the absence of the defendant, John Ruskin, who was unable to attend because of mental instablity, Whistler's performance in the witness box would provide them with plenty of entertainment.

During the proceedings Whistler came to the stand and was examined by Ruskin's defence. Their line of questioning centred on the Ruskinian notion of labour equalling cost, with an emphasis on highly finished pictures of moral significance. In Ruskin's absence his witnesses included Burne-Jones and William Powell Frith, who both advocated this notion of finish and produced pictures of a literary nature. As Whistler's work defied these principles, the ensuing proceedings took on a profound significance in the light of modern art. Whistler's description of a Nocturne as 'an arrangement of line, form and colour' could be read as a precursor to formalism and the beginnings of abstract art. When questioned further on his painting methods and the length of time he took to paint a Nocturne, Whistler's reply was made for posterity.

Ruskin's Defence: 'A labour of two days, then, is that for which you ask two hundred guineas!'

Whistler: 'No; – I ask it for the knowledge of a lifetime.' (Applause).

Whistler v. Ruskin, November 1878

Whistler was followed by his witnesses, who included Albert Moore and William Michael Rossetti, the brother of Dante Gabriel. Moore was to defend the lack of finish in Whistler's work as having a 'large aim not often followed. People abroad charge us with finishing our pictures too much.' He described the Nocturnes as extraordinary in 'that he has painted the air, which few artists have attempted'. It is through these concerns with painterly finish and atmosphere, that Whistler linked up with the French avant-garde, and in particular, the Impressionists.

In the end Whistler won the case, but was awarded only a farthing in damages without costs. Although the costs of the trial contributed to his bankruptcy, Whistler saw the outcome as the artist's triumph over the critics, and within a month published his first brown-paper pamphlet, *Whistler v. Ruskin – Art & Art Critics*, extolling this view.

'WHY DRAG IN VELAZQUEZ?'

The imitator is a poor kind of creature. If the man who paints only the tree, or flower, or other surface he sees before him were an artist, the king of artists would be the photographer. It is for the artist to do something beyond this: in portrait painting to put on canvas something more than the face the models wears for that one day; to paint the man, in short, as well as his features; in arrangement of colours to treat a flower as his key, not as his model.

'Mr. Whistler at Cheyne Walk', *World*, 22 May 1878.

MANY artists turned to portrait-painting as a means of making ends meet. For some artists such as J.E. Millais, G.F. Watts, L. Fildes and J.S. Sargent, portraiture could prove quite a lucrative profession. The walls of the Royal Academy were annually lined with portraits of fashionable people who sought the most popular painter to reproduce their likenesses. In the seventies and eighties, portrait-painting was a competitive business, with many artists vying for success. Despite the advent of photography, having one's portrait painted was still a top priority for the social elite. Some painters saw their task as offering something more than a mere likeness of the sitter, a view epitomised by the work of J. S. Sargent, who could offer a repertoire of styles ranging from Van Dyke to Velazquez. This turning to Old Masters for inspiration and guidance reached its height during this period, when art journals, popular art books, and various Old Master exhibitions were being made available for public consumption. It was in such a milieu that Whistler developed his artistic portraits that went beyond reproducing a likeness to creating a complete work of art. His 'Harmonies' or 'Arrangements' produced in the seventies and eighties set him apart from other portrait painters of the day, but failed to draw the large crowds of fashionable society to his studio.

If you paint a young girl, youth should scent the room: a thinker, thoughts should be in the air; an aroma of the personality.

Whistler. In F. Harris, *Contemporary Portraits*, 1915

49
WHISTLER
Harmony in Grey and
Green:
Miss Cicely Alexander
1872, 190 × 98 cm
Tate Gallery

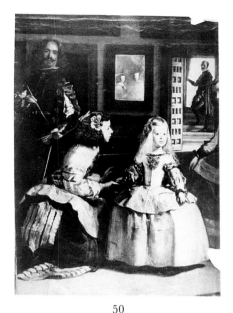

50

VELAZQUEZ

Detail from 'Las Meninas', Prado, Madrid.

This enlarged photograph of the Infanta was in Whistler's studio. Now housed at the University of Glasgow Library.

But it was Velazquez that gave consistency and strength to what in Mr. Whistler might have run into an art of trivial but exquisite decoration. Velazquez, too, had a voice in the composition of the palette, so sober, so grave, reduced to three tints, and those used with such learned knowledge of every possible harmony obtainable from them.

George Moore, *The Speaker*, 11 July 1890

Velazquez, whose Infantas, clad in inaesthetic hoops, are, as works of Art, of the same quality as the Elgin marbles.

Whistler, 'Ten O'Clock' Lecture, 1885.

DURING the early seventies Whistler produced his most aesthetically designed portraits, including the paintings of his mother, Thomas Carlyle and Cicely Alexander. These three works were highly regarded by Whistler and regularly exhibited in major galleries. Whistler's portrait 'Harmony in Grey and Green: Miss Cicely Alexander' was the one commissioned work (fig. 49). The banker and collector William Alexander originally commissioned Whistler to paint all his daughters, although the portrait of Cicely was the only one completed. Begun in 1872 the painting is designed much in the manner of those of the mother and Carlyle, with the figure of the girl held in a tightly balanced composition. Within the design Whistler has paid careful attention to the repetition of colour, as can be seen in his use of yellow, which is picked up in the bow in Cicely's hair, in her sash and shoes and in the cloak behind her. All becomes part of the overall composition, including the dress that Whistler had designed specifically for the picture. Whistler's demands as a portrait painter were not for the weak-hearted, and Cicely sat for over seventy sessions. In his aim to arrive at an effortless look, much laborious scraping down and repainting took place. His method of working 'alla prima' without any pre-liminary studies and his insistence on covering the canvas in each sitting, made his technique very much a hit-and-miss affair, and unsuitable for a demanding clientele.

In the full-length painting Cicely stands like one of Velazquez's portraits of the Spanish Infanta. This comparison was frequently made during and after Whistler's lifetime. Once when compared favourably with the Spanish master, Whistler made his famous riposte 'Why drag in Velazquez?' Such bravado was typical of Whistler, who in fact was deeply influenced by Velazquez and kept in his studio a collection of photographic reproductions after his work, including a detail from 'Las Meninas'. One aspect of Velazquez's art that Whistler adapted for most of his portraiture was to set his figure well within the frame.

Technique

The overall cool tone results from a dark grey imprimatura over the ground and black pigments mixed into most of his colours. To prevent an overworked appearance Whistler rubbed out and scraped away old paint and began again. In this way he kept the paint relatively thin and even. In order to achieve a uniform tone his paint was premixed on the palette. Eventually he achieved his aim to paint 'alla prima' 'with all trace of the means used to bring about the end' disappeared.

This exacting process produced a stable image, with paint of the same hue repeated harmoniously throughout, having the qualities of a sketch yet with sufficient finish to satisfy critics. Most of the paint is relatively opaque. Although some of the pigments mixed in, such as madder, are transparent he avoided deliberate glazing which might discolour inconsistently and destroy the harmony. Since all oil paint becomes more transparent with time, any alterations not rubbed out, such as those to the position of the legs, hand and hat are now visible.

The range of hues Whistler allowed himself is relatively small but the pigment range is broader, involving a number of bright pigments mixed and reduced on the palette. These include cadmium red and yellow, cobalt blue and rose madder. Interestingly the butterflies must have been a later addition because they are mixed with zinc white rather than lead white and also include chrome orange and strontium yellow.

To achieve the flatness of his image he stood a long way back with his canvas well lit in the middle of the room and the sitter against the wall in relative gloom. To help maintain this distance from both sitter and easel, he used long brushes and is reported to have moved backwards and forwards in the studio. In later stages, when painting details, he would spend hours contemplating before precisely placing a spot of paint of the correct tone and predetermined hue. No wonder Cicely looks glum.

STEPHEN HACKNEY AND JOYCE TOWNSEND
Tate Gallery Conservation Depratment

51
WHISTLER
Detail from fig. 49

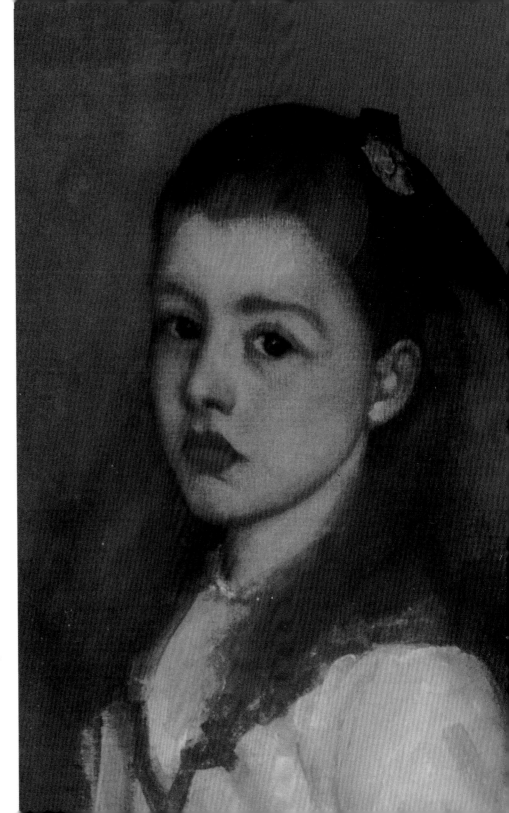

THEODORE DURET was one of the champions of Manet and the Impressionists, and by the early eighties was writing advocating Whistler as a member of the avant-garde. Articles on Whistler would appear in the *Gazette des Beaux-Arts* through the next two decades and in 1904 Duret wrote a book on the artist. When visiting London Duret frequented Whistler's studio where he witnessed the artist painting his portraits of Lady Meux and Lady Archibald Campbell. Late in the spring of 1883, Duret was posing in Whistler's London studio. He had posed fifteen years previously for Manet, whose untimely death that year, perhaps prompted Whistler to attempt a portrait of the critic. It was important to both critic and artist that Duret pose in modern evening dress, keeping alive the Baudelairean concept of painting 'modern life and costume'. The full-length figure of Duret is placed against a grey wall holding a lady's pink domino (cloak) and fan. There is an air of theatricality or expectancy in the portrait, suggesting that there is a world beyond the frame of the picture. To Whistler, however, with his dislike of narrative, such props were used only because a touch of colour was needed at that spot (fig. 53).

52

PERCY JACOMB-HOOD

Whistler's table palette

This table palette departs from the usual hand-held ones. Throughout his career Whistler stressed the importance of preparing the palette before painting and often took up to half an hour to do so.

53
WHISTLER
Arrangement in Flesh
Colour and Black:
Portrait of Theodore
Duret
1883-4, 193.4 × 90.8 cm
Metropolitan Museum of Art,
New York

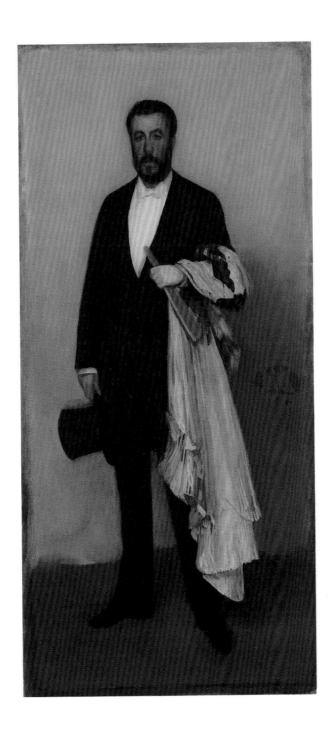

The Art of Design

Art is upon the Town! – to be chucked under the chin by the passing gallant – to be enticed within the gates of the householder – to be coaxed into company, as a proof of culture and refinement...
The people have been harassed with Art in every guise, and vexed with many methods as to its endurance.
They have been told how they shall love Art, and live with it. Their homes have been invaded, their walls covered with paper, their very dress taken to task –

Whistler, 'Ten O'Clock' Lecture;1885.

BY the 1880s the Aesthetic Movement had achieved wide public impact, partly through the art and writings of Whistler and its other great exponent Oscar Wilde, and partly through the caricature and satire which the movement attracted. From the late 1870s the Aesthetes were relentlessly caricatured in the pages of *Punch*, most notably by George du Maurier, and in 1881 Gilbert and Sullivan first staged their comic opera *Patience*. Aimed mainly at Wilde, this brilliant satire was enormously successful, becoming an inextricable part of the history of the movement.

Many of the developments of the Aesthetic Movement took place in the 1860s and 1870s when artists collaborated with designers and architects to create furniture, dress, jewellery, and interiors, as exemplified by the work of William Morris. Originally founded in 1861, his design firm 'Morris, Marshall, Faulkner and Co.' had an explicit aim of applying fine art and craft standards to the design and manufacture of household objects. Morris was a major figure in the blurring of the distinctions between fine and applied art in the latter half of the nineteenth century. Other companies such as Liberty founded in 1875, placed a similar emphasis on decorative design and artistic living. Whistler also played his part in this trend, designing colour schemes for rooms, decorating furniture, houses and exhibitions, and even playing host at artistic dinner parties. In Whistler's fastidious attention to detail, the selection of the menu, the wines, the centrepiece at the dinner-table and even the carefully hand-written invitations to his guests, all came under his guidance. More importantly, his friendship with the architect and designer Edward Godwin proved fruitful, when they collaborated on furniture, decorative and architectural designs.

The White House, unusual in its time for its simplicity, was designed by Whistler and Godwin. When the original plans were submitted for planning permission they were rejected due to their

THE SIX-MARK TEA-POT.
Aesthetic Bridegroom, "It is quite consummate, is it not?"
Intense Bride. "It is, indeed! Oh, Algernon, let us live up to it!"

54
DU MAURIER
The Six-Mark Tea-Pot

Punch, *30 October 1880.*

Caption: *Aesthetic Bridegroom* "It is quite consummate, is it not?" *Intense Bride* "It is indeed! Oh, Algernon, let us live up to it!"
 By the 1880s the Aesthetic Movement had become fashionable to the middle-classes.

lack of exterior decoration. The revised plans by Godwin reveal a few decorative details added to placate the Board of Works, who leased the land. Rejecting the fashion for red-brick and the revised Queen Anne style, Godwin designed the 'White House' using white brick, primarily as a functional building. The windows are situated where Whistler intended them to allow light to flow through the house at irregular intervals. The large roof, in green slate, was both economical and provided a generous studio space for the artist and any pupils. The interior was spaciously designed with clean lines and Japanese details in the woodwork. Although Whistler lived in the house for less than a year, his interest in interior decoration was made apparent throughout. The walls were distempered in shades of yellow, terracotta and white. The mouldings were painted in white and any furniture was of a simple design. Unfortunately the house, built on Tite Street in Chelsea (fig. 55) is no longer standing, but an example of Whistler's colour scheme for a dining room for William Alexander's Aubrey House (London) is still extant. The simplicity of the design with its subtle tonal variation was typical of Whistler's decorative skills (fig. 56).

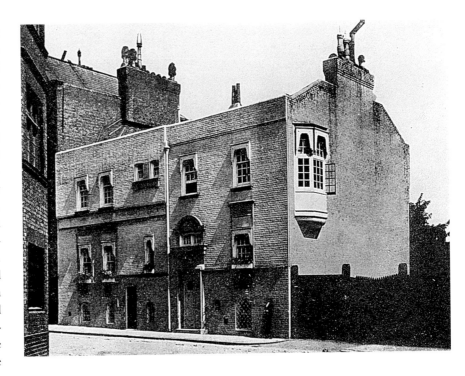

55

White House, Tite Street, Chelsea designed by Whistler and E. W. Godwin, 1877

56

WHISTLER

Colour scheme for the diningroom of Aubrey House, for William Alexander, *c.* 1873, body-colour on brown paper, 18.3 × 12.6 cm

Hunterian Art Gallery (Birnie Philip Bequest) Glasgow

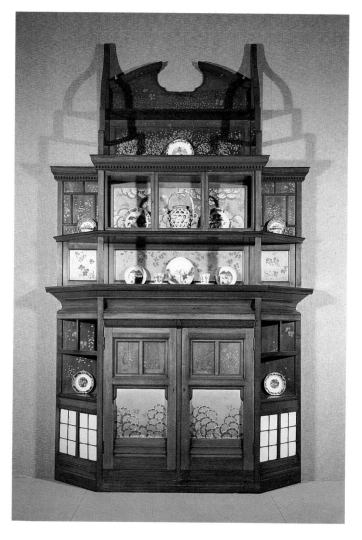

57

E.W. Godwin and Whistler, 'Harmony in Yellow and Gold:
The Butterfly Cabinet', 1878, mahogany, 303 × 190 cm

Hunterian Art Gallery, Glasgow.

Originally a fireplace surround that was part of a display at the 1878
Exposition Universalle in Paris.

WHISTLER'S most famous inter-
ior design, known as 'The Pea-
cock Room', can be seen as a precursor
of Art Nouveau (fig. 59). The room was
part of a redecoration scheme for his
patron Frederick Leyland's newly pur-
chased house in Princes Gate, London.
The dining room was redesigned by
Thomas Jekyll with ornate shelving to
complement and display Leyland's col-
lection of Chinese porcelain. Originally,
Whistler's part was to be neglible, sim-
ply touching up the colour on the Span-
ish leather panels to harmonise with his
painting, 'La Princesse du pays de la
porcelaine'. However, as he worked on
the leather his plans became more am-
bitious, resulting in what Whistler titled
'Harmony in Blue and Gold: The Pea-
cock Room'.

Borrowing ideas from Japan and from
other artists such as Walter Crane and
Albert Moore, Whistler made use of the
motif of the peacock which he repeats
throughout the room (figs. 58,60). A rep-
etition of gold leaf on verdigris blue, the
richness of the design ended up over-
whelming the Chinese porcelain for
which the room was originally designed.
With true showmanship, Whistler held

58

Peacock Room, central shutter
1876–7, 369.5 × 141 cm
Freer Gallery Washington, DC.

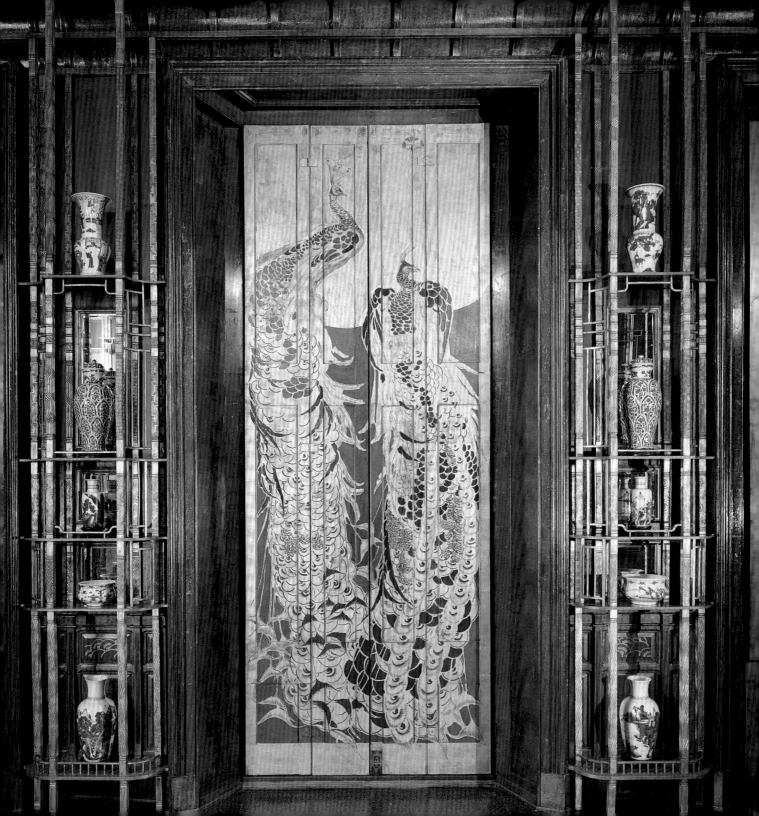

a press conference where he distributed leaflets he had printed about the design. Leyland was offended in a number of ways by Whistler's impudence and refused to pay the full fee of 2,000 guineas demanded by Whistler, sending him £1,000 instead. This was a double insult to Whistler who believed in the old-fashioned system of professionals being paid in guineas whereas workers were paid in pounds.

Whistler added to the breast feathers of one peacock white flecks of paint to symbolise Leyland's ruffled shirt. At its feet he painted the withheld golden guineas. Long after the fight, the young illustrator Aubrey Beardsley visited the room and was impressed by the decoration. The peacock motif can be seen in several of his drawings, including 'The Peacock Skirt' one of his notorious illustrations for Oscar Wilde's equally notorious play, *Salome*. The drawing shows Salome herself wearing a fantastic skirt of peacock feathers (fig. 61).

59

Peacock Room
1876–7
Freer Gallery, Washington DC.

Note Whistler's large painting 'La Princesse du pays de la porcelaine' of 1863-4, over the mantelpiece.

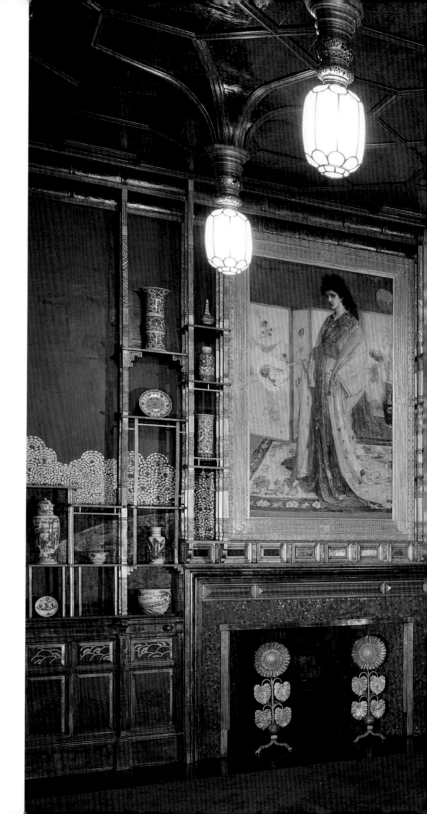

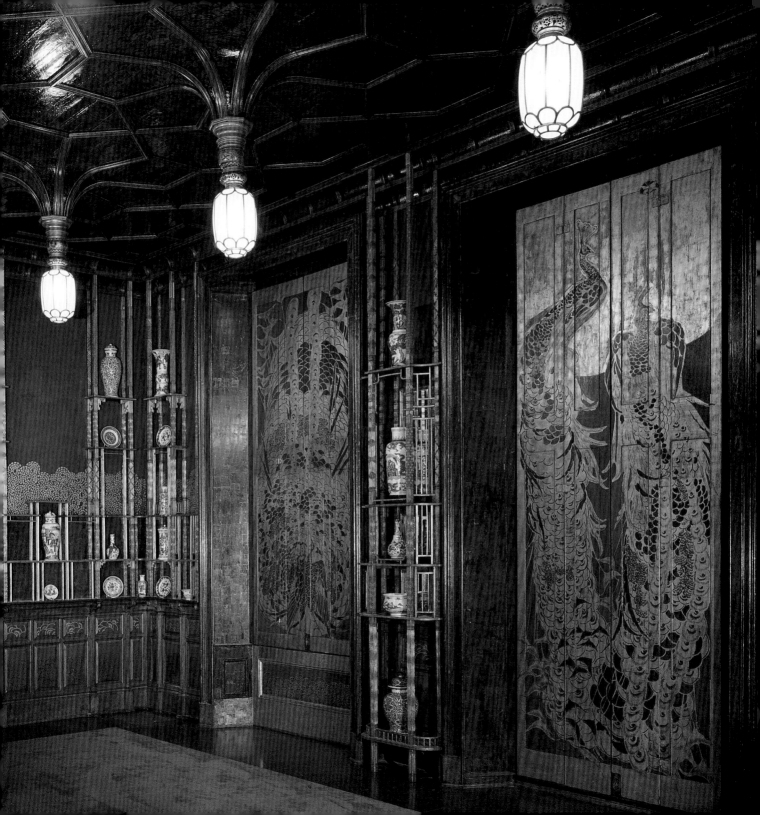

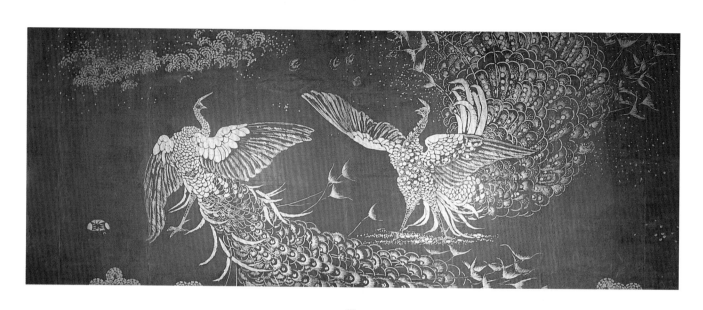

60
Fighting Peacocks, south panel
180.3 x 472.5 cm
Freer Gallery Washington, DC.

61

AUBREY BEARDSLEY

The Peacock Skirt

Line block illustration for Oscar Wilde's
Salome, 1894.

62

WHISTLER

Pen and ink drawing for
exhibition at the Society of
British Artists

20 × 15.8 cm

Ashmolean Museum, Oxford

63

WILLIAM SMALL

'At the Royal Academy',
Graphic, 26 July 1880

The profusion of pictures at the
Academy caused Whistler to
describe it as 'that Bazaar'.

WHISTLER'S obsession with design extended to how his work was presented. From his one-man exhibition of 1874 to his numerous exhibitions of the 1880s he sought to create a harmonious setting for his work. His schemes could often be quite ambitious, as in the case of his second exhibition of etchings of Venice, held in 1883 at the Fine Art Society in London. Whistler's colour scheme, an 'Arrangement in Yellow and White', was designed to set off the etchings. Such attention was paid to the details that Whistler even had the livery of the attendant made up to harmonise with the colour scheme, right down to the yellow socks. This man became known by visitors to the exhibition as the 'poached egg'. When president of the Society of British Artists from 1886 to 1888, Whistler set out to reform the exhibitions, cutting down drastically on the number of admitted works and creating a spacious, two-tiered hanging as seen in his pen and ink drawing (fig. 62). The velarium, an overhead awning, was also designed by Whistler to filter the light. When he was president of the International Society of Sculptors, Painters and Gravers from 1898 to 1903, the spaciousness in the hang and diffusion of overhead light was again implemented. Such reforms in hanging came to characterise modern exhibition design.

INTIMISME

A picture is finished when all trace of the means used to bring about the end has disappeared... The work of the master reeks not of the sweat of the brow – suggests no effort – and is finished from its beginning.

Whistler, 'L'envoie' Proposition, 1884.

'Intimisme' is not the mere record of the small scale events of everyday existence but the means of expressing truths which lie beneath their surface.

M.A. Stevens, *Post-Impressionism*, 1981.

WHISTLER wrote the proposition quoted above for the catalogue of his exhibition entitled 'Notes' – 'Harmonies' – 'Nocturnes'. Held in May 1884 at the commercial gallery Dowdeswells' in New Bond Street, London, this one-man show was unique, with rooms decorated by Whistler in tones of grey, white and flesh colour. This quiet combination of colours allowed for his paintings to harmonise with their setting, thereby creating a complete work of art. This concept was important to Whistler who felt that the beauty of a picture extended to the frame, the wall and the room beyond. Whistler's set of propositions, arguably a defence of the work on display, related to the 'finish' and scale of a painting. Many of the sixty-seven pictures exhibited were in the mediums of watercolour, pastel or oil on panel. Almost all of the pictures were small with some measuring less than four by six inches. Working on such a scale after the large portraits and Nocturnes suggests that Whistler was moving towards a more in-

64

WHISTLER

An Orange Note: Sweet Shop

1884, oil on panel, 12.2 × 21.5 cm

Freer Gallery, Washington DC

Painted in St Ives, Cornwall. First exhibited in 1884 at Dowdeswells' Gallery.

65

WHISTLER

Pink Note: The Novelette

Early 1880s, watercolour, 25.3 × 15.5 cm

Freer Gallery, Washington DC.

Exhibited in 1884 at Dowdeswells' Gallery. This small painting depicts Whistler's mistress Maud Franklin reading in their bedroom. Note the simplicity of the interior decoration from the elegant table in the foreground to the fans tacked over the mantlepiece.

timate rendering of nature. Many of these paintings could have been done in a few hours and are marked by a freshness and facility often lacking in his larger work. Having moved away from the 'memory method' used for the Nocturnes, Whistler painted these pictures *en plein air*, with the immediacy of seeing nature firsthand. In his recent visit to Venice he had worked on this smaller scale from nature, producing a quantity of etchings, pastels and watercolours of the city. Furthermore, in his awareness of the work of the Impressionists, small canvases painted directly from nature, he was possibly inspired to paint in a similar fashion. Yet, unlike his French counterparts whose application of paint was often visible in impastoed patches, Whistler used paint more thinly, often blending the colour tonally to harmonise with the background.

The saleablity of these smaller works in the commercial galleries of London encouraged Whistler to continue producing work of this nature until his death in 1903. Some of these paintings were of subjects from his studio and personal life and reveal a more intimate side of the artist. The paintings were often mounted in deep reeded frames of gold leaf that set the work off like a gem. Whistler's ability to work in the different mediums of oil, watercolour, pastel, etching and lithography reveal him as an extremely diverse artist. His sensitivity to each medium is demonstrated in his skill at capturing the qualities

unique to that method. Whistler's work in these various mediums was exhibited both in commercial galleries in London as well as at the Society of British Artists and the International Society of Sculptors, Painters and Gravers, where he served as president, and where the work of French and other European artists was on display alongside the more avantgarde of the British sector. Two contributors to the first exhibition in 1898 were the Pierre Bonnard and Edouard Vuillard, who were part of the Nabis movement. In their studies of domestic interiors the intimate quality found in Whistler's smaller paintings is frequently present. This can also be discovered in the work of Gwen John, whose quiet paintings reflect her training with Whistler at the Academie Carmen in Paris during the late 1890s (fig. 69).

66

WHISTLER

The Purple Cap

1890s, pastel on grey-brown paper

Freer Gallery, Washington DC

This intimate study of the model (a Pettigrew sister) and child is very subtle in its delicate use of colour.

FAME AND LEGACY

During the seventies and eighties Whistler's public image was largely that of an artistic eccentric, especially after the trial against Ruskin (see page 51). Adding to this notoriety was the play, *The Grasshopper*, produced in 1877 by John Hollingshead. In the English version Whistler was caricatured as a 'Harmonist', while in the original French version Degas was the object of ridicule. During the London performance an actual caricature of Whistler by Pelligrini was wheeled onstage. Whistler again was ridiculed with Oscar Wilde in Gilbert and Sullivan's *Patience*, in the character of the aesthete.

Whistler was well known to the public through his paintings and etchings, letters to the press, publications, exhibitions, and his presidency of the Society of British Artists and later the International Society of Sculptors, Painters and Gravers (ISSPG). Throughout his adult life he associated with key figures in certain literary circles, including the poet Swinburne and much later the Symbolist poet Stephane Mallarmé. Introduced by Monet, Mallarmé was to translate Whistler's 'Ten O'Clock' lecture into French in 1888. Whistler soon became a regular at Mallarmé's *Mardis*, a Tuesday evening gathering of the Parisian artistic elite. Although Whistler had little comprehension of the poet's work, they shared beliefs in aestheticism and the doctrine of 'art for art's sake'. Mallarmé's dictum 'To *name* an object is to suppress three-quarters of the pleasure... to *suggest*, that is the dream' could equally apply to Whistler. It was during this period that Mallarmé, together with the art critic Duret was instrumental in acquiring Whistler's 'The Painter's Mother' for the Luxembourg Museum in Paris. Duret, himself a champion of Whistler's work, wrote extensively on the artist, during and after his death. He was to make the link between Whistler's painting and Debussy's music, and contributed to bringing the artist's work to the notice of French Symbolist circles. Although Whistler himself was not a Symbolist, his work proved to be influential in both the literary and artistic circles. Writers such as J.K. Huysmans in his essay on Whistler in *Certains* (1889) compared him with the poet Verlaine, who at times 'conjures up subtle suggestions' and 'lulls us with a sort of incantation whose occult spell escapes us'. In Huysmans' book *A Rebours* (Against Nature) the main character des Esseintes, was modelled on the great aesthete Comte Robert de Montesquiou, who in turn modelled for Whistler in the early 1890s. The English poet Arthur Symons was also brought within the circle of Whistler, and several of his Symbolist poems can be viewed as literal translations of the master's paintings.

In 1905 a memorial exhibition of Whistler's work was held in London, Boston and Paris and was widely attended by the general public and numerous artists. However, by the end of the first decade his reputation was already being eclipsed by more recent developments in modern art which were marked in 1910 by the first Post-Impressionist exhibition held in London at the Grafton Galleries and organized by Roger Fry. The advent of the First World War affected all art markets and sales of Whistler's work went into decline for several decades. However, by the 1950s and 1960s interest in Whistler began to reawaken with the publication of several books and an Arts Council exhibition held in London. In 1984 the Freer Gallery in Washington held a major exhibition of Whistler's work to celebrate the 150th anniversary of his birth. With the 1994-5 retrospective exhibition held at the Tate, the Musée d'Orsay, Paris, and the National Gallery in Washington, more people than ever before will have

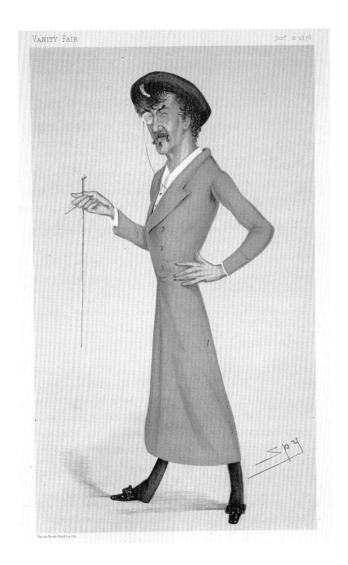

67

SPY (LESLIE WARD)

A Symphony

Vanity Fair, 12 January 1878
Published when Whistler's acrimonious pamphlet,
Whistler v. Ruskin, Art and Art Critics was
at the height of popularity.

an unequalled opportunity to see a wide range of Whistler's work has been made available to the public.

Viewed from an art historical perspective Whistler's reputation as an artist suffered because he belonged to no movement and has been viewed in isolation, set apart from the social and artistic history of his time. However, in the last twenty years diligent scholarship has reassessed his position within the larger scope of nineteenth-century art. A Centre for Whistler Studies which caters to archival research has been set up at Glasgow University Library, where many of his papers are now housed (Birnie Philip Bequest). Major galleries which display his work include the Hunterian Gallery (University of Glasgow), the Musée d'Orsay, the Tate Gallery, and numerous institutions in the United States, including the Freer Gallery of Art and National Gallery in Washington.

68
PAUL MAITLAND
Autumn, Kensington Gardens
Oil on panel, *c.* 1906
Tate Gallery

WHILE Whistler's fame has been capricious, his legacy has lived on through a number of artists who were either pupils or followers, the better known being Walter Sickert and Gwen John. Sickert trained with Whistler in his studio from the early 1880s and maintained a friendship with the artist until 1896 when he became involved in a lawsuit over transfer lithography against Joseph Pennell, another of the Whistler camp. While Sickert's music halls are indebted to Degas, his landscape and portrait painting reveal a close appreciation of Whistler's sensitivity to colour and tone. Sickert was one of a circle of followers which included the 'London Impressionists' who numbered in their rank Philip Wilson Steer, Theodore Roussel and Paul Maitland. In Maitland's paintings of Kensington Gardens, Chelsea and the Thames, the evocative atmosphere of Whistler's work is translated to an intimate scale. Maitland's small panel painting 'Autumn, Kensington Gardens' is a good example of the tonal qualities so important in Whistler's own work. By the eighties Whistler often painted landscape on small panels prepared with a grey wash, working *en plein air* to arrive at a fresh spontaneous image.

Gwen John provides another interesting link with Whistler. In the late 1890s she was a pupil in his briefly run Académie Carmen in Paris, where she came under his influence after initially training at the Slade in London. One of the more enduring tenets of Whistler's

69

GWEN JOHN

Convalescent

c. 1910 to mid-1920s

Tate Gallery

This quiet painting reflects some of the more intimate works by Whistler of domestic interiors, such as his watercolour 'The Novelette' (fig. 65).

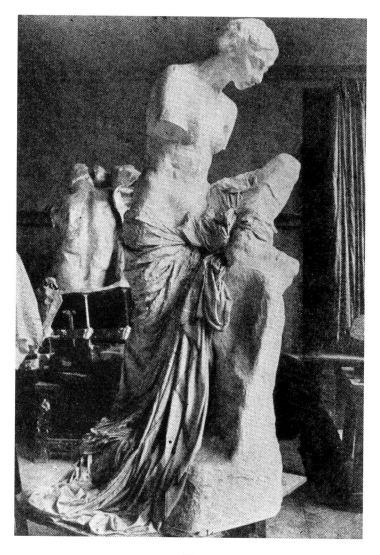

70

RODIN

Project for a Monument to Whistler

c. 1906

Musée Rodin, Paris

teaching was the importance of preparing the palette and the subtle range of tones within a colour. In Gwen John's application of this principle she developed an elaborate system of numbering her tones in preliminary studies before working the painting up to a more finished state. Throughout her work she practised this adherence to a close tonal range of colours.

Gwen John was also to make an appearance as the model for Rodin's memorial to Whistler, commissioned by the International Society in 1906 in memory of their president. Rodin, who took over as president of the society, spent a number of years on the work, which was never completed for its site on the Chelsea Embankment. A copy of Rodin's bronze was also intended for a site in Whistler's birthplace of Lowell, Massachusetts.

Whistler's application of the concept of 'art for art's sake', as exemplified in his emphasis on the qualities of the painted surface, can be seen as his greatest contribution to twentieth-century art. Freed from the fetters of narration, painters could begin to explore the unlimited possibilities of 'line, form and colour', marking crucial developments in modern art. Such claims can be seen in work as diverse as Picasso's 'Blue' and 'Rose' periods to Rothko's vast colour fields, where Whistler's art is still evoked.

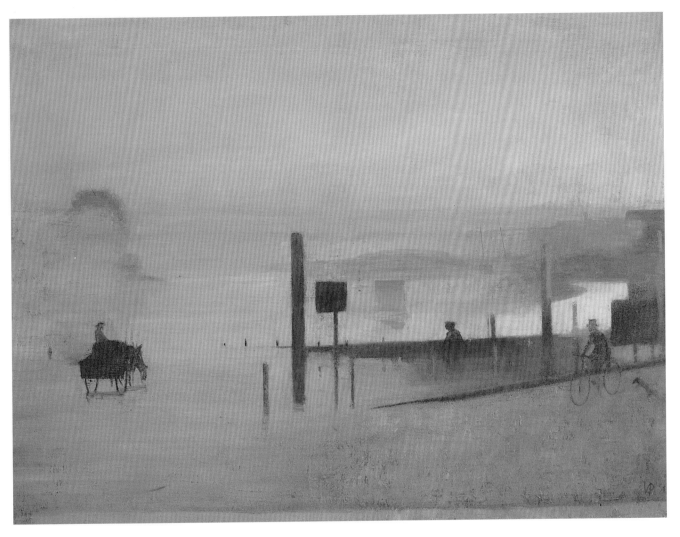

71

VICTOR PASMORE

The Quiet River: The Thames at Chiswick

1943-44

Tate Gallery

This early painting is from a series on the Thames and predates his
more abstract pictures.

CHRONOLOGY

1834 11 July, born in Lowell, Massachusetts, son of Lieutenant George Washington Whistler (civil engineer) and Anna Matilda McNeill Whistler.

1837 Family moved to Stonington, Connecticut, where father in charge of constructing railroad.

1840 Move to Springfield, Massachusetts when father appointed chief engineer on Western Railroad.

1843 Family moves to St Petersburg, Russia where father worked as civil engineer on St. Petersburg – Moscow railroad.

1845 14 April. Whistler begins lessons at the Imperial Academy of Fine Arts in St Petersburg; enrolled until March 1846.

1847 During a period of convalescence, recovering from rheumatic fever, Whistler is given volume of Hogarth's engravings. Visits England in summer and attends half-sister Deborah's wedding with Seymour Haden. Family returns to St Petersburg.

1848 Summer spent again in England, Whistler remains for his health. Attends a school briefly, by January 1849 staying with the Hadens in London. Sir William Boxall paints portrait of Whistler and takes the boy to Hampton Court to see the Raphael cartoons.

1849 7 April, father dies. By August family departs for America. Family lives in Pomfret, Connecticut.

1851 1 July Whistler enrols at West Point Military Academy as cadet-at-large under Commandant Robert E. Lee.

1854 16 June Whistler discharged for failing chemistry. 7 November given post in the drawing division of Coast Survey office where he learns rudiments of etching.

1855 February resigns from Coast Survey, makes plans to leave America and receives visa for France. Leaves for England in September. By November is living in Paris, and registered at the Ecole Imperiale et Speciale de Dessin. Year of the Exposition Universelle in Paris.

1856 By June, enters Gleyre's studio, Paris. Meets George du Maurier, Poynter and Thomas Armstrong as well as Henri Martin and the sculptor Drouet.

1857 Does copies in the Louvre and the Luxembourg Museum. Visits Manchester Art Treasures exhibition with Henri Martin.

1858 Visits Germany and Northern France with Ernest Delannoy on etching tour. On return to Paris prints 'French Set' with Delatre. Meets Fantin-Latour in the Louvre. Influenced by Courbet. 'Société de Trois' formed with Whistler, Fantin and Legros. Travels to London where 'French Set' published by brother-in-law, Haden. Paints 'At the Piano', a study of half-sister Deborah and niece Annie.

1859 Back in Paris, 'At the Piano' rejected by Salon jury. Shows work at Bonvin's studio where it is praised by Courbet. Moves to London, stays in rooms in Wapping. Begins 'Thames Set' etchings.

1860 Exhibits 'At the Piano' at Royal Academy where it receives good reviews. Shares a studio with Du Maurier in London. Painting 'Wapping' is begun. First painting of Joanna Hiffernan, Whistler's mistress

1861 Exhibits 'La Mère Gérard' at RA. Possibly meets Manet in Paris during summer months. Begins painting 'The White Girl'.

1862 January: Thames etchings exhibited at Martinet's gallery in Paris, praised by Baudelaire. Exhibits 'The White Girl' at Morgan's Gallery, Berners Street, London. Meets D.G. Rossetti and C.A. Swinburne. Visits Guethary in autumn with Joanna Hiffernan.

1863 Moves to 7 Lindsey Row in Chelsea. Meets Greaves brothers. Visits Paris with Swinburne, introduces him to Manet. 'The White Girl' rejected by Salon then exhibited at the *Salon des Refusés*. Mother arrives from America and lives with Whistler. Begins to paint Oriental subjects.

1864 Poses for Fantin-Latour's 'Homage to Delacroix'. Exhibits 'Wapping' at the RA. Begins 'The Little White Girl'.

1865 Exhibits 'The Little White Girl' and 'Old Battersea Bridge' and two Oriental compositions at RA. Meets Albert Moore, who replaces Legros in the 'Société de Trois'. Begins 'Symphony in White, no.3'. Brother now living in London, having run the blockades during

American civil war. Visits Trouville with Jo and meets up with Courbet. Paints seascapes. Courbet paints 'La Belle Irlandaise', using Jo as the model.

1866 February: travels to South America where Chileans engaged in war against Spain. Stays in Valparaiso where he paints several harbour scenes. Returns to London in October.

1867 Moves to 2 Lindsey Row. Fights with Haden in Paris. Exhibits 3 paintings at RA, including 'Symphony in White, no. 3'. First time Whistler exhibits with musical title. Exhibits at Salon and Exposition Universelle in Paris. Writes to Fantin-Latour rejecting Courbet's realism. Begins 'Six Projects'.

1868 Lives and works for several months at 62 Great Russell Street, opposite the British Museum. Begins large picture 'Three Girls'.

1869 Begins painting portraits of Leyland family.

1870 Exhibits 'The Balcony' at the RA.

1871 Publishes 'Thames Set' of etchings. Begins painting his 'moonlights' soon to be given title 'Nocturnes' of the Thames. Paints portrait of his mother. Exhibits with dealer galleries in London including Society of French Artists run by the Parisian dealer Durand-Ruel in exile from Franco-Prussian War.

1872 Exhibits 'Arrangement in Grey and Black: Portrait of the Painter's Mother' at RA after near-rejection. Does not again exhibit at RA.

1873 Exhibits at Durand-Ruel's in Paris. Paints portraits of Thomas Carlyle and Cicely Alexander. Helps decorate Alexander's Aubrey House.

1874 One-man exhibition in the Flemish Gallery, Pall Mall. On display are 13 oils, including number of portraits, 36 drawings, 50 etchings and one painted screen.

1875 Mother moves to Hastings for health. Paints Nocturnes of Cremorne Gardens and portraits of Maud Franklin.

1876 Begins decoration on dining-room of Leyland's London house in Prince's Gate, the 'Peacock Room'.

1877 Invites press to visit 'Peacock Room', entitled 'Harmony in Blue and Gold'. Exhibits 8 works at newly opened Grosvenor Gallery including 'The Falling Rocket'.

Ruskin criticises the work in *Fors Clavigera* and Whistler sues him for libel. Commissions E.W. Godwin to build the White House in Tite Street.

1878 Exhibits again at the Grosvenor Gallery with 7 paintings. Designs the 'Butterfly Cabinet' with Godwin and exhibits at the Exposition Universelle in Paris. Moves into White House. November 25-6 wins libel action against Ruskin but receives only one farthing in damages and must pay own costs. Publishes pamphlet *Whistler v. Ruskin: Art and Art Critics*.

1879 Declares bankruptcy. Exhibits 5 oils at Grosvenor Gallery. In September leaves for Venice with Maud to complete commission from Fine Art Society of 12 etchings. White House sold.

1880 Produces much work in Venice including etchings, pastels, watercolours and a few oils. By November returns to London and in December exhibits 12 'Etchings of Venice' at the Fine Art Society.

1881 Exhibits 53 pastels at one-man show at Fine Art Society. Mother dies on January 31. Begins portraits of Lady Meux. Meets Oscar Wilde.

1882 Continues portraits of Lady Meux and Lady Archibald Campbell. Exhibits at Salon. Walter Sickert becomes pupil.

1883 Exhibition of Venice etchings at the Fine Art Society. Exhibits 'The Painter's Mother' at Salon. Reviewed by Duret whose portrait Whistler begins to paint. Exhibits at Georges Petit Gallery in Paris and the Grosvenor Gallery in London. Visits Holland. Late winter in St Ives, Cornwall with pupils Mortimer, Menpes and Walter Sickert.

1884 Exhibits with the Societe des XX in Brussels. One-man exhibition at Dowdeswell's Gallery. Exhibits at Salon and Grosvenor gallery. Begins portrait of Beatrice Godwin. Elected member Society of British Artists, exhibits in winter show. Exhibition at Dublin Sketching Club. Visits Holland.

1885 Gives 'Ten O'Clock' lecture in Princes Hall. Exhibits at Salon and Society of British Artists. Visits Belgium, Holland and France.

1886 Publishes 'Set of Twenty-six Etchings ' of Venice with Dowdeswell's. Second one-man exhibition at Dowdeswell's. Exhibits at Salon and in Brussels. Elected president Society of British Artists, exhibits with them.

1887 Exhibits with Georges Petit Gallery in Paris, with over 50 small oils, watercolours and pastels. Acquires royal charter for Society of British Artists. Invites Monet to exhibit with society. Visits Holland and Belgium.

1888 Exhibits with Société des XX in Brussels and with Durand-Ruel in Paris. Resigns from Royal Society of British Artists. Exhibits at inaugural exhibition of New English Art Club. Meets Stéphane Mallarmé, who translates his 'Ten O'Clock' lecture into French. Exhibits in Munich. Marries Beatrice Godwin, the widow of E.W.Godwin. Travels to France. Elected honourary member of Royal Academy of Fine Arts in Munich.

1889 Exhibition of work held at Wunderlich's in New York. Sickert organises retrospective exhibition at College for Working Men and Women. Banquets held for Whistler in Paris and London to celebrate awards. Visits Amsterdam. Made Chevalier of the Legion d'Honneur.

1890 Publishes *The Gentle Art of Making Enemies*. Lawsuit against unauthorised version. Exhibits at Salons in Paris and Brussels.

1891 Begins portrait of Montesquiou. Portrait of Carlyle is

bought by the Corporation of Glasgow and 'The Painter's Mother' bought by the Musée Luxembourg in Paris, and thus eventually becomes the first work by a foreign artist to enter the collection of the Louvre. Part of hanging committee for Walker Art Gallery in Liverpool.

1892 Made Officier of the Legion d'Honneur. Retrospective exhibition is held at the Goupil Gallery in London. Moves to Paris with Beatrice.

1894 Du Maurier's novel *Trilby* appears in serialised form in *Harper's Magazine*, with Whistler appearing as Joe Sibley, the idle apprentice. Whistler's protests led to an apology from *Harper's* and when published in book form in 1895 all references toWhistler were removed.

1895 Court-case against Sir William Eden, where after an appeal Whistler is allowed to keep portrait he had begun of Eden's wife. Exhibits in Antwerp and Venice. Visits Normandy and Lyme Regis in Dorset for wife's health. Produces number of lithographs, etchings and paintings.

Exhibition of lithographs at the Fine Art Society.

1896 Beatrice Whistler dies. Whistler visits northern France.

1897 Opens unsuccessful Company of the Butterfly to sell his work. Falls out with Sickert over trial with Joseph Pennell on transfer lithography. Exhibits with the Societe Nationale des Beaux-Arts. Visits France.

1898 Elected president of International Society of Sculptors, Painters and Gravers in London. Lives in Paris where Academie Carmen is opened, and visits classes once a week.

1899 Exhibits at first World of Art Exhibition at St Petersburg. Visits Rome and Florence. Travels to Dordrecht, London and back to Paris.

1900 Elected honourary academician of Academy of St Luke, Rome. Exhibits at the Exposition Universelle in Paris. Brother William dies. Visits Holland. Académie Carmen

closes in spring. Visits Gibraltar, Algiers, Tangiers and Corsica.

1901 Elected honourary member of Academie des Beaux-Arts in Paris. Returns from Corsica to London. Visits Paris where he sells house and closes up his studio.

1902 Lives in London. Exhibits at Société Nationale des Beaux-Arts. Visits Holland.

1903 Receives honourary degree of Doctor of Laws from University of Glasgow. Health deteriorates. Dies on 17 July.

1904 Memorial exhibition in Boston.

1905 Memorial exhibitions in London and Paris.

NOTE This chronology is based on McLaren Young, Margaret Macdonald, Robin Spencer and Hamish Mills, *The Paintings of James McNeill Whistler*, 1980 publication and research.

SELECT BIBLIOGRAPHY

MANUSCRIPT SOURCES

Centre for Whistler Studies, Glasgow University Library, Glasgow, Scotland.

Charles Lang Freer Papers, Freer Gallery of Art/ Sackler Gallery Archives, Smithsonian Institute, Washington, D.C.

Pennell Collection, Whistler Material, Library of Congress, Manuscript Division, Washington, DC.

STANDARD WORKS

Anderson, Ronald and Koval, Anne, *James McNeill Whistler: Beyond the Myth*, John Murray Publishers, London, 1994.

Curry, David Park, *James McNeill Whistler at the Freer Gallery of Art*, Freer Gallery of Art, Smithsonian Institution and W.W. Norton and Co., New York and London, 1984.

Dorment, Richard and MacDonald, Margaret, *James McNeill Whistler*, Tate Gallery Publications, London, 1994.

Fine, Ruth, (editor), *James McNeill Whistler, A Re-examination*, Studies in History of Art, vol. 19, Washington, DC, 1987.

Getscher, Robert H. and Marks, Paul G., *James McNeill Whistler and John Singer Sargent, Two Annotated Bibliographies*, Garland Publishing Inc., New York and London, 1986.

Getscher, Robert H., *The Pastels of James Abbott McNeill Whistler*, John Murray Publishers, London, 1991.

Lochnan, Katherine A., *The Etchings of James McNeill Whistler*, Yale University Press, New Haven and London, 1984.

MacDonald, Margaret, *Whistler's Mother's Cook Book*, Paul Elek, London, 1979.

Mayne, Jonathan (ed., trans.), *Charles Baudelaire: The Painter of Modern Life*, Phaidon Press Limited, 1964.

Merrill, Linda, *A Pot of Paint: Aesthetics on Trial in Whistler v. Ruskin*, Smithsonian Institution Press, Washington and London, 1992.

Pennell, Elizabeth Robins and Joseph, *The Life of James McNeill Whistler*, 2 vols., William Heinemann and J.B. Lippincott Co., London and Philadelphia, 1908.

Pennell, Elizabeth Robins and Joseph, *The Whistler Journal*, J.B. Lippincott Co., Philadelphia, 1921.

Spencer, Robin, *Whistler A Retrospective*, Hugh Lauter Levin Associates, Inc., New York, 1989.

Taylor, Hilary, *James McNeill Whistler*, Studio Vista, London, 1978.

Whistler, James McNeill, *The Gentle Art of Making Enemies*, William Heinemann, London and later New York, 1890, and subsequent editions.

Young, Andrew McLaren, MacDonald, Margaret, Spencer, Robin, and Miles, Hamish, *The Paintings of James McNeill Whistler*, Yale University Press, 2 vols., New Haven and London, 1980.

PHOTOGRAPHIC CREDITS